LEGENDARY
TROY
NEW YORK

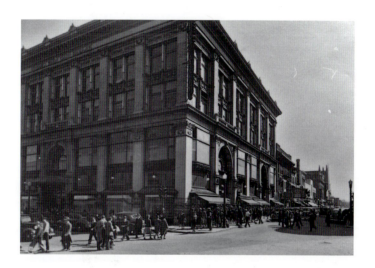

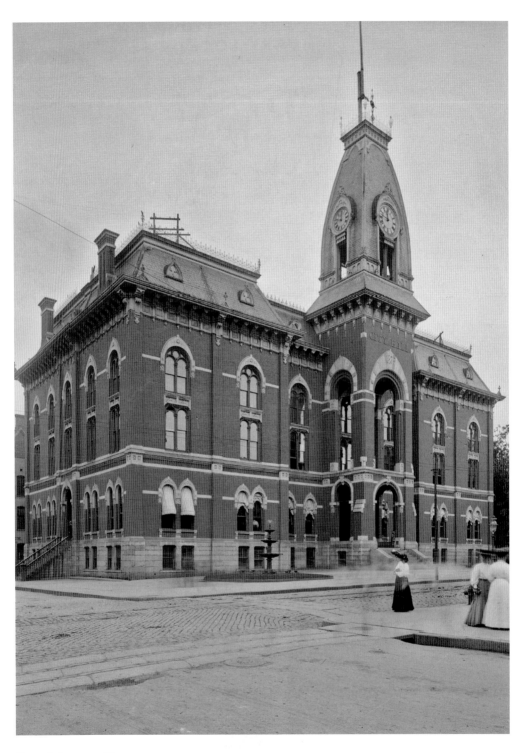

Page 1: See page 43
Above: See page 64

LEGENDARY LOCALS
OF
TROY
NEW YORK

DON RITTNER

To Jennifer, Jason, Christopher, Kevin, and Jackson

Copyright © 2011 by Don Rittner
ISBN 978-1-4671-0007-6

Published by Legendary Locals, an imprint of Arcadia Publishing
Charleston, South Carolina

Printed in the United States of America

Library of Congress Control Number: 2011938416

For all general information, please contact Arcadia Publishing:
Telephone 843-853-2070
Fax 843-853-0044
E-mail sales@arcadiapublishing.com
For customer service and orders:
Toll-Free 1-888-313-2665

Visit us on the Internet at www.arcadiapublishing.com

On the Cover: From left to right:
(TOP ROW) Dan Brouthers (Courtesy of Library of Congress; see page 101), Chester Arthur (Courtesy of Library of Congress; see page 10), John Heenan (Author's collection; see page 101), Joseph B. Carr (Courtesy of Library of Congress; see page 21), Boston Corbett (Courtesy of Library of Congress; see page 22).
(MIDDLE ROW) Carl Erickson (Author's collection; see page 67), John Evers (Courtesy of Library of Congress; see page 92), John A. Griswold (Courtesy of Library of Congress; see page 12), Lou Ismay (Author's collection; see page 89), George Henry Thomas (Courtesy of Library of Congress; see page 28).
(BOTTOM ROW) John Morrissey (Courtesy of Library of Congress; see page 121), Margaret Olivia Slocum (Author's collection; see page 95), Michael "King" Kelly (Courtesy of Library of Congress; see page 117), George Phelps (Courtesy of John Casale; see page 53), Amos Eaton (Author's collection; see page 84).

CONTENTS

Acknowledgments 6

Introduction 7

CHAPTER ONE Military and Political Leaders 9

CHAPTER TWO Inventors, Businesspeople, and Notables 31

CHAPTER THREE Scientists, Educators, and Writers 81

CHAPTER FOUR Athletes and Entertainers 99

Index 127

ACKNOWLEDGMENTS

All images in this book are from the personal collections of the author unless otherwise stated. Special thanks go to Scott R. Schroeder; Mark McCarty; Dan Strohl and Keith Marvin; Dan Meneely; John Casale; Colin A. Fries; Sister Louise and John Diefenderfer; Rocky Sawyer; Dick Allen; Mark A. Conger; Cathy Connolly; Rensselaer County Historical Society; Michael Lopez; John Wolcott; Minnesota Historical Society; Marieke Leeverink; Tim Hauser; University of Oregon Libraries; American Heritage Foundation; National Park Service; US Marine Corps; New York State Archives, New York Public Library; University of Michigan; HABS; National Library of Medicine; Institute Archives and Special Collections, Rensselaer Polytechnic Institute; Royal Feltner; NASA HQ History Program Office; Patrice M. Kane; Fordham University Archives; Terry Wasielewski; the Sage Colleges' Libraries; Sam Newton, University of Florida Communications; Michael Helfenbein; Yale Office of Public Affairs & Communications; Rick Blomquist; Tony Gill; Robert Fuller; Mark Pattison; and Mike BuBose. Apologies to those left out.

INTRODUCTION

Situated about 150 miles north of New York City on the Hudson River, Troy was named after the fabled city of the same name honored in epic poems by Homer. Legendary Troy rose from the ashes several times over thousands of years, and our modern Troy has attempted to rediscover itself several times, although over a much shorter time period.

We too have our Helen of Troy, Mount Ida, and Mount Olympus, and our Trojan War, although our version was more political than military when the city annexed nearby Lansingburgh in 1900. Troy rose from farmland tilled by Dutch settlers in the 17th century to become an ethnically diverse industrial powerhouse during the 19th century. It flexed its muscle in almost every aspect of American life and left an indelible mark on the American experience. There are few events in American history where you cannot find some Trojan involved. Much of the American infrastructure has "Made in Troy, NY" stamped on it, and today's citizens have benefited from the blood, sweat, and tears of many early and contemporary Trojans.

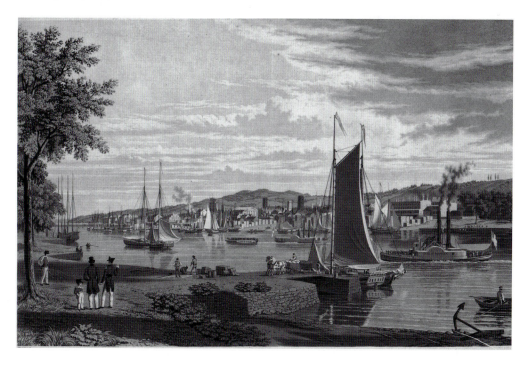

Troy from the West Bank of the Hudson
This 1838 painting by H.J. Megarey shows Troy as viewed from the west bank of the Hudson in front of the US Arsenal.

Troy has become famous over the years as the home of the American icon Uncle Sam, as the "Collar City," for inventing detachable collars and cuffs, and as a mill town, supplying much of the country's iron and steel during the 19th century. But Troy is so much more than that.

Epictetus wrote, "You will confer the greatest benefits on your city, not by raising its roofs, but by exalting its souls. For it is better that great souls should live in small habitations, than that abject slaves should burrow in great houses." This book attempts to illuminate the lives of some "great souls," more than 100 Trojans who have contributed to American history in the fields of government and politics, business, invention, the military, science, education, literature, sports, and entertainment. Also included are notable achievements that do not fit neatly into any of the above fields, and some profiles of women who did great things in an era when women were expected to confine their talents to the home. Telling a Trojan woman that she had to be idle in the 19th century was like telling an eagle not to fly.

With a book this size, I had to be very selective about whom to include, and I must admit it was not easy. This book could easily have become a series, as there are hundreds of other legendary Trojans who made lasting impressions and could have been included within these pages. Due to the present limits of the book, each individual bio is short, but that should whet your appetite for finding out more about your favorite Trojans.

You can find more details about this book's heroes by visiting your local library. Yes, the Internet is helpful too, but those who live in Troy should visit the Troy Room at the Troy Public Library, where the stories of many of our early heroes wait for your discovery. The stories of those who came before you—yes, those who walked on those very same streets under your feet—will give you a new appreciation for the Troy you now call home. It could be that the person walking past you today is in his or her own way making history for the future.

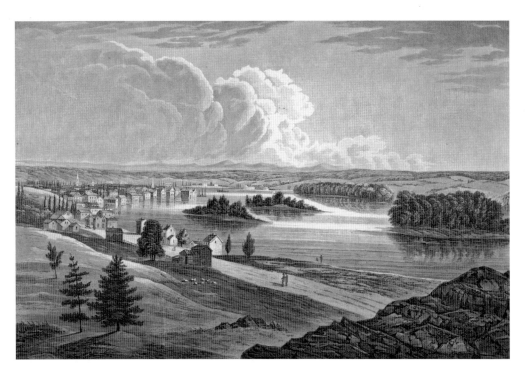

Troy from Mount Ida
This view of Troy by William G. Wall was painted between 1821 and 1825 and is incorrectly labeled. The view is actually from Mount Olympus, which is located in the northern part of the city, near present-day Middleburgh Street.

CHAPTER ONE

Military and Political Leaders

Trojans have been in the forefront when it comes to serving their country. They have served as local aldermen, mayors, governors (Jay Hammond, Frank Black, William Marcy), and even presidents (Chester Arthur). Trojan John Wilkinson founded Syracuse, and Edward McCabe even attempted to create a blacks-only state in the western part of the country. They have served as leaders in wars from the Revolution to modern-day conflicts, and three of them have won the military's highest honors for their bravery. Industrialists John Griswold and John Winslow of Troy financed the construction of the USS *Monitor*, which turned the Civil War in favor of the North. New military tactics were invented by John LaMountain, the first aerialist to use a balloon for military reconnaissance. Troy's Thomas Farrell was second in command of the Manhattan Project, and Francis Terry McNamara served as an ambassador to four locations. All of these men gave 100 percent in serving their country.

LEGENDARY LOCALS

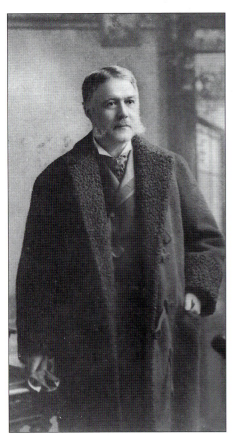

**Chester Alan Arthur
(October 5, 1829–November 18, 1886)**
Arthur was the 21st president of the United States (1881–1885). Arthur grew up in North Troy (Lansingburgh) and attended the Lansingburgh Academy. He lived at 626 First Avenue (pictured) in 1846 (currently standing but unoccupied). He attended Union College in Schenectady in 1845 and taught school at a one-room schoolhouse in the town of Schaghticoke on Verbeck Street, earning $15 a week. His father was the Reverend William Arthur, who preached at the Baptist church on the northeast corner of 117th Street and Third Avenue. After ascending to the Oval Office following the assassination of James A. Garfield, President Arthur became a champion for civil service reform, a surprise to many because he had been linked to the New York City Republican machine early in his political career. He is buried in Albany Rural Cemetery.

Lansingburgh Academy
Arthur attended school at Lansingburgh, which today is part of the Troy Public Library system.

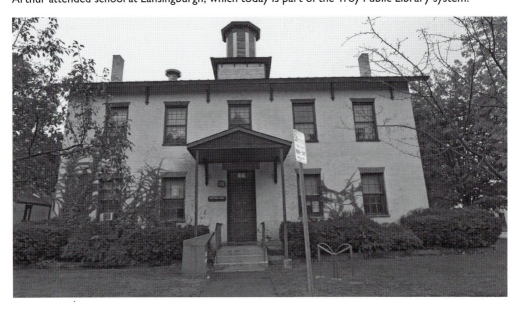

CHAPTER ONE: MILITARY AND POLITICAL LEADERS

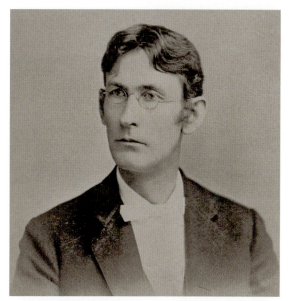

Frank Swett Black
(March 8, 1853–March 22, 1913)

Black was a newspaper editor, lawyer, member of the US House of Representatives (1895–1897), and Republican governor of New York (1897–1898). Nicknamed "the judge" as a boy, he taught school at the age of 17 and worked for the *Troy Whig* and *Troy Times* while studying law. Black was one of the lawyers who helped prosecute Bat Shea, who killed Robert Ross during the election riots in Troy on March 6, 1894. He entered politics through "circumstances, and got out as quickly as possible," according to one newspaper obituary. While governor, Black opposed a bill that would have prevented editorial cartoons from being published in newspapers. He lost support for reelection because of his stand for freedom of the press, and in 1898, he was defeated in the state convention by Theodore Roosevelt.

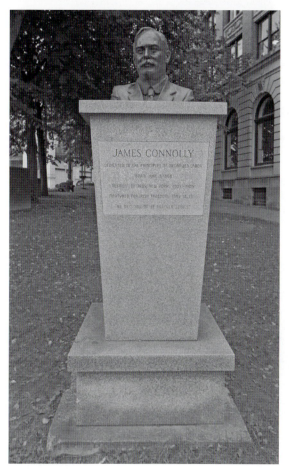

James Connolly
(June 5, 1868–May 12, 1916)

An Irish socialist, Connolly helped found the Irish Socialist Republican Party in 1896 and the party's newspaper the *Workers Republic* in 1898 in Dublin. From 1903 to 1905, he lived in Troy. To support his family of six, he worked for the Metropolitan Life Insurance Company. While in America, he became involved in Irish politics and was a prolific writer. His book *Labour in Irish History* exposed the horrible working conditions endured by the British and Irish working class. When he returned to Ireland, he led an unsuccessful revolt against English rule in 1916. He was arrested, tried, and shot to death on May 12, 1916. He did not live to see a free Ireland, but his famous quote rings today: "A revolution will only be achieved when the ordinary people of the world, us, the working class, get up off our knees and take back what is rightfully ours." In 1986, the James Connolly Society of Canada and the United States erected a monument to Connolly in Troy.

John A. Griswold (1817–October 31, 1872)

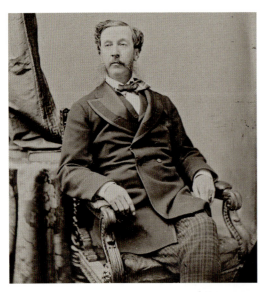

Griswold was elected mayor of Troy in 1855. He later became a US representative from New York, serving as a Democrat in 1862 and as a Republican from 1864 to 1871. Starting out working in a wholesale drugstore, he began manufacturing local iron and in 1857 owned one of the largest iron mills in the area. He purchased the first rights to use the Bessemer Steel process in America and built a two-and-a-half-ton plant with John Winslow and A.L. Holley. He was instrumental in financing the ironclad USS *Monitor* designed by John Ericsson. He took the financial risk, not waiting for the government to furnish a contract. Griswold purchased the Rensselaer Iron Company, which helped produce some of the iron products for the *Monitor*. (Courtesy of Library of Congress.)

The USS *Monitor*

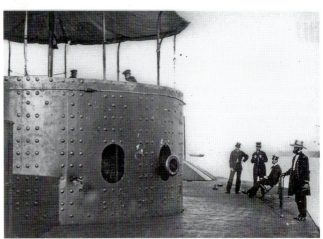

The *Monitor* was financed in part by Griswold. This image shows 3rd Engineer Robinson Hands from Troy with his hand to his hip on deck. Hands died when he went down with the ship as it sunk off Cape Hatteras, North Carolina, on December 31, 1862. (Courtesy US Navy, Naval Historical Center.)

Jay Sterner Hammond (July 21, 1922–August 2, 2005)

Hammond was a Troy-born politician who was the State of Alaska's fourth governor from 1974 to 1982. Hammond's educational career included petroleum engineering and biological sciences. He was a Marine pilot in World War II with the famous Black Sheep Squadron in China, and later a bush pilot and hunting guide. Before he became governor, he was a state representative (1959–1965), state senator (1967–1972), and mayor of Bristol Bay Borough from 1972 to 1974. As governor, he was involved with the construction of the Trans Alaska Pipeline, and the Alaska Permanent Fund, which invested oil revenues to cover state budgets and as a side effect paid dividends to Alaska residents. He abolished state income taxes. From 1985 to 1992, he hosted the *Jay Hammond's Alaska* TV series. While filming an episode, his daughter, a camera operator, and a producer for the show were killed in a rafting accident and Hammond nearly lost his life as well. He wrote two autobiographies. (Courtesy of Wikipedia.)

CHAPTER ONE: MILITARY AND POLITICAL LEADERS

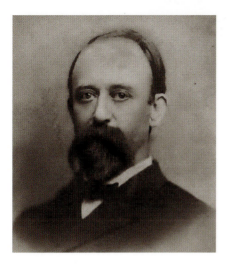

Lucius Frederick Hubbard
(January 26, 1836–February 5, 1913)

Hubbard was a Troy-born Civil War soldier and later a politician in Minnesota. He started in the printing business and was publisher of two Minnesota newspapers, the *Red Wing Republican* and the *Goodhue County Republican*. He joined the 5th Minnesota Volunteer Infantry when the Civil War broke out. He was appointed brigadier general for his services at the Battle of Nashville and later ran for the State Senate. He became part owner of the Midland Railroad and decided to run for governor of Minnesota in 1881. He served from 1882 to 1887 and was a promoter of public health intervention among other issues. After political service, he went back to the railroads, but at the outbreak of the Spanish-American War in 1898, he was appointed to help in that effort by President McKinley.

William L. Marcy
(December 12, 1786–July 4, 1857)

Marcy was a lawyer practicing in Troy as early as 1811, later becoming the city's recorder. However, after siding with the Bucktails, who opposed DeWitt Clinton, he was removed from office in 1818. He was editor of the *Troy Budget*, originally the *Northern Budget*, first published in Lansingburgh and then moved to Troy. Marcy became a member of the Albany Regency, politicians who controlled the state legislature from 1821 to 1838. He served as adjutant-general of the New York State Militia (1821–1823), New York State comptroller (1823–1829), and an associate justice of the New York Supreme Court (1829–1831). He was New York's governor from 1833 to 1838, losing to William Seward and thus ending the Albany Regency's era of dominance. He is credited with the saying "to the victor belong the spoils," and with originating the political spoils system. The highest mountain in New York, Mount Marcy (pictured), is named for him. (Courtesy of Library of Congress.)

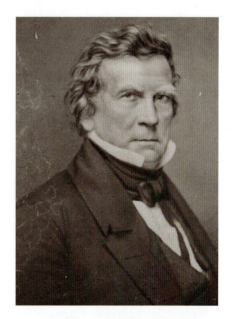

13

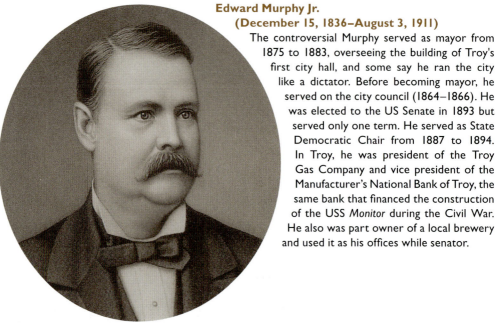

Edward Murphy Jr. (December 15, 1836–August 3, 1911)

The controversial Murphy served as mayor from 1875 to 1883, overseeing the building of Troy's first city hall, and some say he ran the city like a dictator. Before becoming mayor, he served on the city council (1864–1866). He was elected to the US Senate in 1893 but served only one term. He served as State Democratic Chair from 1887 to 1894. In Troy, he was president of the Troy Gas Company and vice president of the Manufacturer's National Bank of Troy, the same bank that financed the construction of the USS *Monitor* during the Civil War. He also was part owner of a local brewery and used it as his offices while senator.

Edward W. Pattison (April 29, 1932–August 22, 1990)

A Troy attorney and former US representative, Pattison started in his father's law firm—Pattison, Sampson, Ginsberg & Griffin. He received the New York State Bar Association's Root-Stimson Award for Community Service Work in 1990. He began his career in 1960 heading the local Kennedy-Johnson campaign and became known as a reformer in the 1960s. He was the Rensselaer County treasurer from 1969 to 1974 and was elected to Congress in 1974 for two terms, the first Democrat since the Civil War to be elected from Troy. While in Congress, he was instrumental in revising US copyright law. After leaving Congress, he became a fellow at the Institute of Politics at Harvard University's Kennedy School of Government. In 1979, he was chairman of the Congressional Institute on the Future. He returned to practicing law and teaching at Rensselaer Polytechnic Institute (RPI). He was only 58 when he died in 1990. (Courtesy of Mark Pattison.)

CHAPTER ONE: MILITARY AND POLITICAL LEADERS

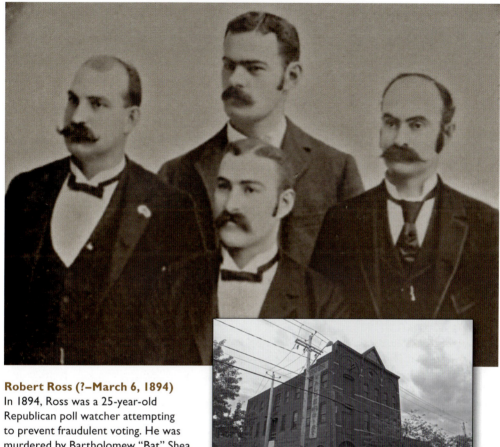

Robert Ross (?–March 6, 1894)
In 1894, Ross was a 25-year-old Republican poll watcher attempting to prevent fraudulent voting. He was murdered by Bartholomew "Bat" Shea during an election riot in the city's 13th Ward. Ross's brother William was also shot but survived. Ross's family ran Ross Valve, where he worked, and he was a volunteer for the Esek Bussy Fire Company. Ross was labeled a martyr in the local press. Shea and another man, John McGough, were arrested and convicted for Ross's murder. Shea was executed in 1894 on Independence Day, and McGough received 20 years. Many blamed the riots on Ed Murphy, the Democratic boss who was mayor of the city and later a US senator. Ross Valve (pictured) still makes water valves in Troy.

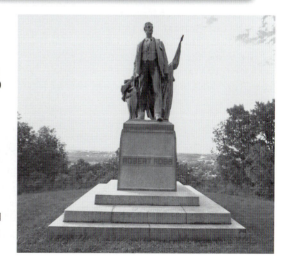

Robert Ross Monument
The monument at Oakwood Cemetery, overlooking the city, was paid for and erected by a woman's group in Troy called the Robert Ross Monument Association.

LEGENDARY LOCALS

Martin I. Townsend
(February 10, 1810–March 8, 1903) (LEFT)

A Troy lawyer and politician, Townsend defended fugitive slave Antonio Louis in 1842 and in 1860 defended his own coach driver, Charles Nalle, another fugitive slave who was rescued by a Troy mob. Townsend and others paid for Nalle's freedom. He became famous for defending the "Veiled Murderess," Henrietta Robinson. He was district attorney of Rensselaer County in 1842, alderman on the city council for two terms, and served as one of the regents of New York State (1873–1903). In 1874, he went to Congress to serve in the House of Representatives.

Edward P. McCabe
(October 10, 1850–March 12, 1920)

Troy-born McCabe worked on Wall Street as a clerk, and in 1878, migrated to Nicodemus, Kansas, where a growing black population was emerging. When Graham County was established in 1880, he was appointed county clerk and a Republican state auditor, but left the area after the town changed. He purchased over 300 acres in the new territory of Oklahoma in 1889 and began attracting black settlers to his land that grew to 200 residents by 1891. It became the town of Langston. He promoted more black settlements and by 1910 there were 30 all-black towns in the state. His goal was to make Oklahoma an all-black state. When the new state legislature passed segregation laws in 1907, he fought the laws but lost.

AME Church
This church in Nicodemus was part of the growing black community in which McCabe lived. (Courtesy of Library of Congress.)

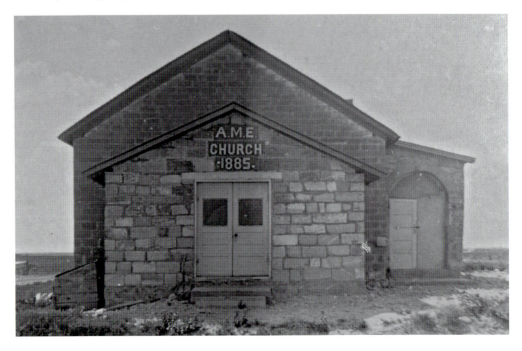

CHAPTER ONE: MILITARY AND POLITICAL LEADERS

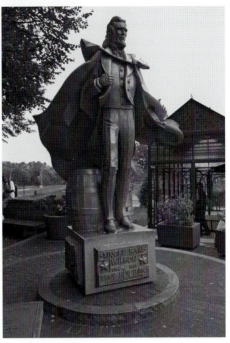

Samuel Wilson
(September 13, 1766–July 31, 1854)

Wilson and his brother Ebenezer started making bricks at the west foot of Mount Ida at Sixth Avenue and Ferry Street in 1789. In 1793, they leased a lot on the northeast corner of Second and Ferry Streets and built a small house. They also created a butcher business and built a large slaughter and packing house on the north bank of the Poestenkill. With more than 100 men working for them, they slaughtered more than 1,000 head of cattle a week. Wilson was known to his friends and family around Troy as "Uncle Sam." Sam and Ebenezer advertised as early as 1805 that they could butcher and pack 150 head of cattle a day. When the War of 1812 broke out, Sam secured a job as meat inspector for the Northern Army and also sought contracts to supply meat. One of the accounts Wilson inspected was owned by Elbert Anderson. Anderson had secured a year contract to supply all rations to troops in New York and New Jersey. In October 1812, he advertised for bids to supply 2,000 barrels of pork and 3,000 barrels of beef, to be packed in barrels of white oak. The Wilsons got the job. The barrels were then marked "E.A.-U.S.," referring to Anderson and United States. When asked what the initials meant, a Wilson workman said it referred to Elbert Anderson and "Uncle Sam." The Uncle Sam name stuck as a nickname for the United States and was attributed to Sam Wilson. If it wasn't for Sam Wilson, the US would be known as "Brother Jonathan," a prior nickname for the country attributed to George Washington's reliance on the advice of Connecticut's governor Jonathan Trumbull.

Uncle Sam Statue
This statue of "Uncle Sam" Wilson is in downtown Troy.

Uncle Sam's Tombstone
"Uncle Sam" Wilson is buried in Oakwood Cemetery. The gravesite does not seem elaborate enough for the icon of America.

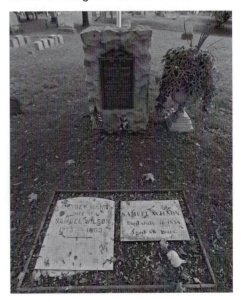

John Wilkinson (September 30, 1798–September 19, 1862)

An abolitionist postmaster turned politician and banker, Troy-born Wilkinson was better known as the founder of Syracuse. While postmaster he helped lay out the new village streets on the "Walton Tract" as town planner of Syracuse and gave it its name in 1820. He served as village clerk in 1925 and later as assemblyman in 1834 and 1835 representing his district. He founded the Syracuse Bank in 1838 and was president of the Syracuse & Utica Railroad and later a director of the New York Central Railroad. This is a map of the village of Syracuse in 1874.

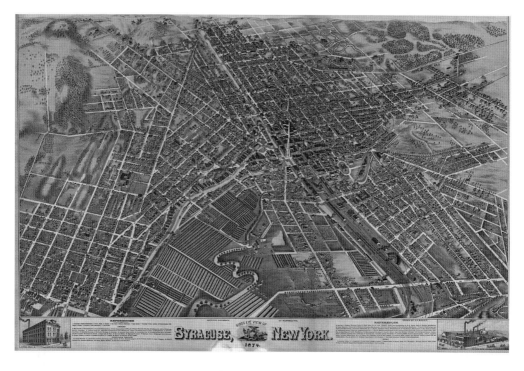

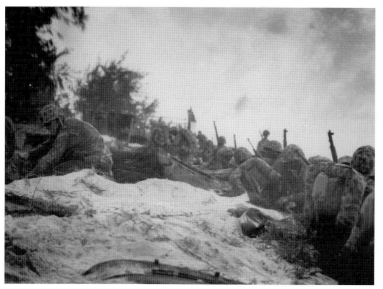

LEFT: Assault troops await orders to attack enemy shortly after they had come ashore at Saipan. (Courtesy of U.S. Coast Guard, 127-N-83928.)

RIGHT: With a canvas tarpaulin for a church and packing cases for an altar, a Navy chaplain holds mass for Marines at Saipan. (Courtesy of US Marine Corps 127-N-82262.)

Thomas A. Baker (June 25, 1916–July 7, 1944)

Troy's Sgt. Thomas Baker served in the Army's 105th Infantry, 27th Infantry Division in World War II, and received the military's highest honor, the Congressional Medal of Honor. He received a citation that read as follows: "For conspicuous gallantry and intrepidity at the risk of his life above and beyond the call of duty at Saipan, Mariana Islands, 19 June to 7 July 1944. When his entire company was held up by fire from automatic weapons and small-arms fire from strongly fortified enemy positions that commanded the view of the company, Sgt. (then Pvt.) Baker voluntarily took a bazooka and dashed alone to within 100 yards of the enemy. Through heavy rifle and machinegun fire that was directed at him by the enemy, he knocked out the strong point, enabling his company to assault the ridge. Some days later while his company advanced across the open field flanked with obstructions and places of concealment for the enemy, Sgt. Baker again voluntarily took up a position in the rear to protect the company against surprise attack and came upon 2 heavily fortified enemy pockets manned by 2 officers and 10 enlisted men which had been bypassed. Without regard for such superior numbers, he unhesitatingly attacked and killed all of them. Five hundred yards farther, he discovered 6 men of the enemy who had concealed themselves behind our lines and destroyed all of them. On 7 July 1944, the perimeter of which Sgt. Baker was a part was attacked from 3 sides by from 3,000 to 5,000 Japanese. During the early stages of this attack, Sgt. Baker was seriously wounded but he insisted on remaining in the line and fired at the enemy at ranges sometimes as close as 5 yards until his ammunition ran out. Without ammunition and with his own weapon battered to uselessness from hand-to-hand combat, he was carried about 50 yards to the rear by a comrade, who was then himself wounded. At this point Sgt. Baker refused to be moved any farther stating that he preferred to be left to die rather than risk the lives of any more of his friends. A short time later, at his request, he was placed in a sitting position against a small tree. Another comrade, withdrawing, offered assistance. Sgt. Baker refused, insisting that he be left alone and be given a soldier's pistol with its remaining 8 rounds of ammunition. When last seen alive, Sgt. Baker was propped against a tree, pistol in hand, calmly facing the foe. Later Sgt. Baker's body was found in the same position, gun empty, with 8 Japanese lying dead before him. His deeds were in keeping with the highest traditions of the U.S. Army." (Courtesy of US Marines.)

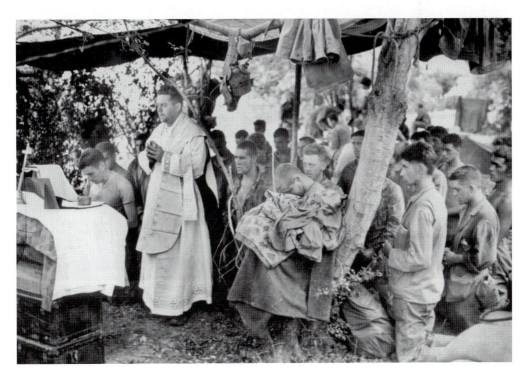

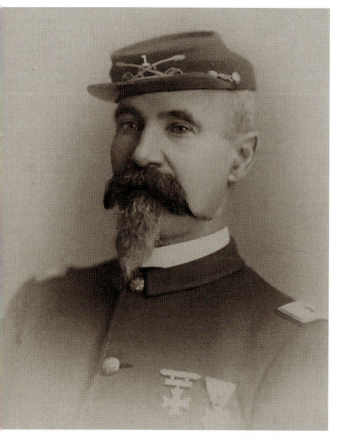

Frazier Augustus Boutelle (September 12, 1840–February 12, 1924)

Born in Troy, Frazier was a soldier in the US Army for over 50 years and an early conservationist. He fought in the Civil War (Antietam, Spotsylvania, Cold Harbor, Wilderness, Gettysburg, and the Second Battle of Bull Run), in the Indian Wars (against the Apache, Piute, Snake, Modoc, and Nez Perce), and recruited soldiers for World War I. He was appointed superintendent of Yellowstone National Park, where he served in 1889 and 1890. While there, he supported the conservation of bison, advocated stocking streams with fish, promoted the use of established campgrounds, and developed a system for quick response to wildfires. He was popular for his promotion of the protection of wildlife and landscapes and their natural features. He was fired in 1891 for demanding more resources to fight wildfires. He returned to duty in 1905 as a recruiting officer, and during World War I, was the oldest serving officer of his time. (Courtesy University of Oregon Libraries.)

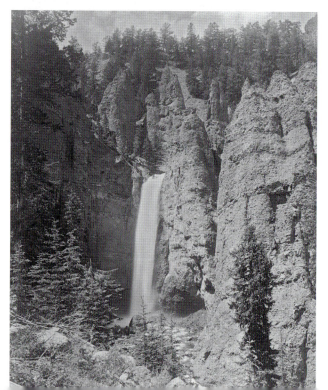

Yellowstone Falls

This picture of the falls was taken in 1892 at Yellowstone by William Henry Jackson (also from Troy) shortly after the time Boutelle was superintendent. (Courtesy of Library of Congress.)

CHAPTER ONE: MILITARY AND POLITICAL LEADERS

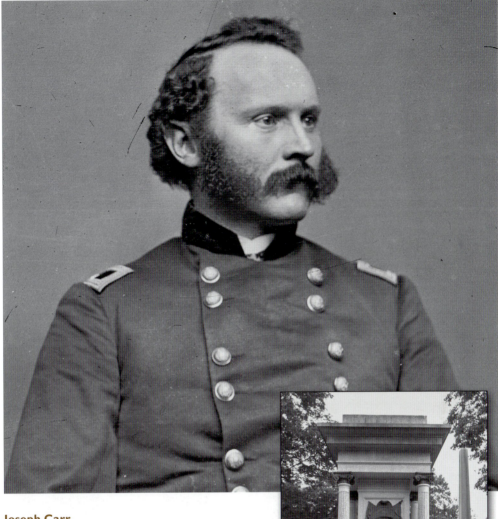

Joseph Carr
(August 15, 1828–February 25, 1895)
Carr was a Troy cigar maker. On May 10, 1861, he became a colonel of the Second New York Volunteers and landed at Fort Monroe on May 24, being the first to encamp on Virginia soil. He commanded the celebrated "Jersey Brigade," and led them throughout the engagements of the Orchard and Malvern Hill. At Bristoe Station, one of the toughest battles of the Civil War, he earned the title of "the Hero of Bristoe." He was at Bull Run and Chantilly, and at Fredericksburg and Chancellorsville his heroics received special mention in the war reports. After the war, he returned to Troy and started manufacturing chains. He was secretary of state of New York from 1880 to 1885. (Courtesy of Library of Congress.)

Carr's Tombstone
Carr is buried in Oakwood Cemetery. The bronze plaque representing his profile in uniform depicts a man proud of his military career.

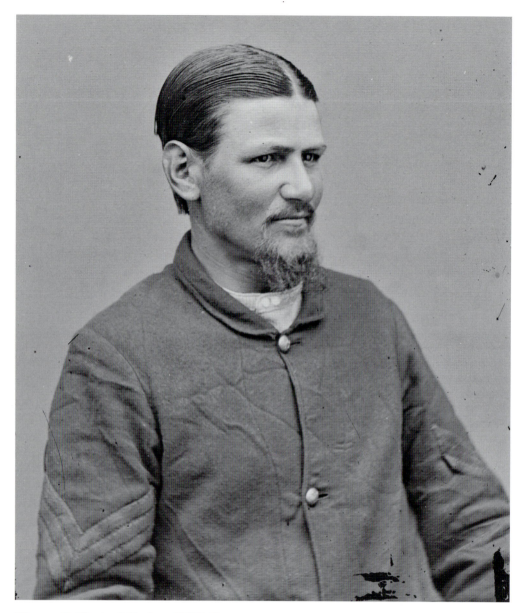

Thomas P. (Boston) Corbett (1832–?)
Corbett came to Troy in 1839 and became a hatter; some speculate that he developed Mad Hatter disease from the mercury used on felt. Corbett became an expert marksman and exhibited this talent during the Civil War, enlisting three times. He became a prisoner after refusing to surrender to troops led by Confederate colonel John Mosby, the famous Gray Ghost. He was one of 26 soldiers selected to pursue John Wilkes Booth after he assassinated Abraham Lincoln. On April 26, 1865, they cornered Booth in a barn in Virginia, and Corbett shot Booth in the head between the wallboards of the barn. He was thrown in the brig for not taking Booth alive, but was exonerated by then secretary of war Edwin Stanton. Corbett collected a share of the reward money and moved to Kansas, where he was declared insane and later escaped from the Topeka Kansas Insane Asylum never to be seen or heard of again. (Courtesy of Library of Congress.)

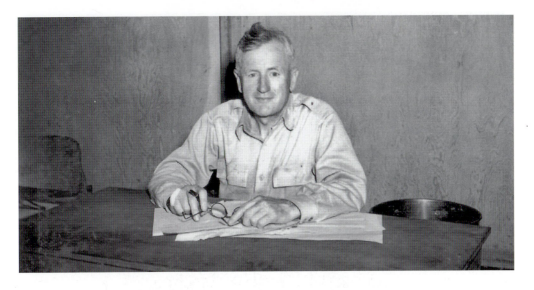

Thomas Francis Farrell (December 3, 1891–April 11, 1967)
The Troy-born Farrell was a major general in the Army and deputy commanding general, chief of field operations, and executive officer to Manhattan Project head honcho Gen. Leslie Groves. He was a graduate of Troy's Rensselaer Polytechnic Institute and worked on the Panama Canal (1913–1916). Later he headed the New York State Department of Public Works's construction and engineering division in 1926. Farrell helped build the Burma Road in World War II. When he began working on the Manhattan Project, he supervised the Trinity Test at Alamogordo, New Mexico, with J. Robert Oppenheimer. After the test he wrote, "It was a great new force to be used for good or for evil. There was a feeling in that shelter that those concerned with its nativity should dedicate their lives to the mission that it would always be used for good and never for evil." When he hand-delivered orders to Col. Paul Tibbets, commander of the plane *Enola Gay* that was assigned to drop the bomb, he signed the bomb, "To Hirohito, with love, T.F. Farrell." After the bombs were dropped in Japan, he led a team of scientists to inspect the effects. In his later years, he worked in New York City consulting on bridge and road projects. (Courtesy American Heritage Foundation.)

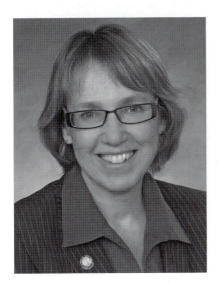

Cathy Connolly (September 15, 1956–Present)
Connolly was the first openly gay member of the Wyoming House of Representatives. Born in Troy, she graduated from Catholic High in 1974. After earning a PhD in sociology and a law degree from SUNY Buffalo, she moved to Laramie, Wyoming, in 1992 to teach at the University of Wyoming, where she is a professor in the Gender and Women's Studies Program. She has authored numerous articles on law, justice, and sexuality, and served on the board of Wyoming Equality, an organization that supports gay and lesbian issues. (Courtesy Cathy Connolly.)

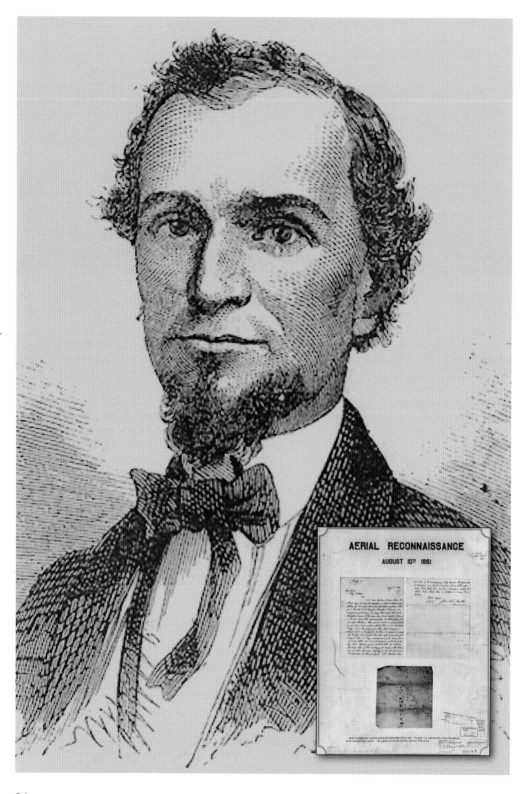

John LaMountain (1830–1878) (LEFT)
LaMountain was an early American balloonist (aeronaut) from Lansingburgh who is credited with conducting the first aerial reconnaissance of enemy territory in a hot air balloon during the Civil War. In 1858, LaMountain built a large balloon, the *Atlantic*, for crossing the Atlantic Ocean. Over 60 feet in diameter and constructed with Chinese silk, it had a wicker basket for the crew and below that a lifeboat with propellers. He teamed up with financier and Vermont potter Oliver A. Gager and John Wise, already a veteran of air ascents since 1835. On July 1st, his team along with a newspaper reporter left St. Louis on a test run to the east. They traveled 1,150 miles in some 20 hours at 57 miles per hour, eventually crashing into a tree in Jefferson County. It was publicized as the greatest aerial voyage in history and set an official world distance record for nonstop air flight that would not be broken until 1910. It was the first airmail delivery as Wise literally "dropped" off a bag of mail consigned by the US Express Company. LaMountain tried again in September in Watertown with another reporter, but hit fast winds at 100 miles per hour. They ended up in the Canadian wilderness and went a week without food, finally being rescued by lumberjacks. He tried another ascent at the Washington County Fair in 1860, but due to high winds and lack of suitable gas, he failed to get airborne. At the outbreak of the Civil War, LaMountain thought that he could engage his balloons to spy on Confederate locations. In July 1861, he made two successful ascensions at Fort Monroe, going up to 3,000 feet, noticing cannon positions, finding a Confederate encampment about three miles beyond his view, and spotting a large force on the James River, eight miles above Newport News. (Courtesy NASA HQ History Program Office.)

Reconnaissance Report (LEFT INSET)
This original reconnaissance report by LaMountain shows Confederate positions during the Civil War. (Courtesy Library of Congress.)

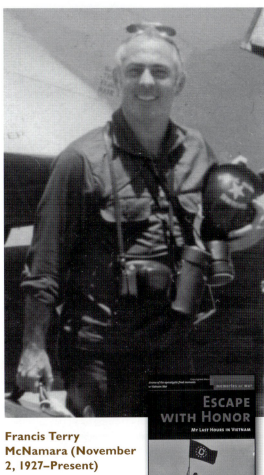

Francis Terry McNamara (November 2, 1927–Present)
Troy-born McNamara spent most of his life in the military and government service. He graduated from Russell Sage College in 1953 and spent more than 35 years in foreign services, including seven African assignments. He was consul general in Quebec (1975–1979) and deputy chief of mission at the Beirut Embassy for two years (1985–1987). He is the author of *Escape with Honor: Last Hours in Vietnam* with Adrian Hill and *The French in Black Africa*. He was US ambassador to Gabon, Sao Tome, and Principe (1982–1984), and Cape Verde (1989–1992). When he was ordered to abandon his Vietnamese coworkers during the evacuation of Vietnam in 1975, instead he led 300 Vietnamese, 18 American, and 6 Filipino employees on a dangerous 70-mile river journey to safety. He currently lives in Virginia. (Courtesy of Wikipedia.)

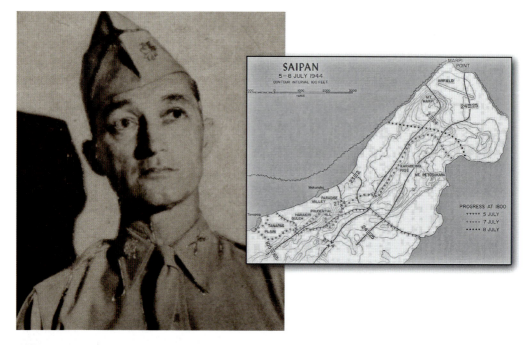

William J. O'Brien (1899–July 7, 1944)

O'Brien received the Medal of Honor for his heroic actions during the Battle of Saipan in World War II. His citation read as follows: "For conspicuous gallantry and intrepidity at the risk of his life above and beyond the call of duty at Saipan, Marianas Islands, from 20 June through 7 July 1944. When assault elements of his platoon were held up by intense enemy fire, Lt. Col. O'Brien ordered 3 tanks to precede the assault companies in an attempt to knock out the strongpoint. Due to direct enemy fire the tanks' turrets were closed, causing the tanks to lose direction and to fire into our own troops. Lt. Col. O'Brien, with complete disregard for his own safety, dashed into full view of the enemy and ran to the leader's tank, and pounded on the tank with his pistol butt to attract 2 of the tank's crew and, mounting the tank fully exposed to enemy fire, Lt. Col. O'Brien personally directed the assault until the enemy strongpoint had been liquidated. On 28 June 1944, while his platoon was attempting to take a bitterly defended high ridge in the vicinity of Donnay, Lt. Col. O'Brien arranged to capture the ridge by a double envelopment movement of 2 large combat battalions. He personally took control of the maneuver. Lt. Col. O'Brien crossed 1,200 yards of sniper-infested underbrush alone to arrive at a point where one of his platoons was being held up by the enemy. Leaving some men to contain the enemy he personally led 4 men into a narrow ravine behind, and killed or drove off all the Japanese manning that strongpoint. In this action he captured 5 machineguns and one 77-mm. fieldpiece. Lt. Col. O'Brien then organized the 2 platoons for night defense and against repeated counterattacks directed them. Meanwhile he managed to hold ground. On 7 July 1944 his battalion and another battalion were attacked by an overwhelming enemy force estimated at between 3,000 and 5,000 Japanese. With bloody hand-to-hand fighting in progress everywhere, their forward positions were finally overrun by the sheer weight of the enemy numbers. With many casualties and ammunition running low, Lt. Col. O'Brien refused to leave the front lines. Striding up and down the lines, he fired at the enemy with a pistol in each hand and his presence there bolstered the spirits of the men, encouraged them in their fight and sustained them in their heroic stand. Even after he was seriously wounded, Lt. Col. O'Brien refused to be evacuated and after his pistol ammunition was exhausted, he manned a .50 caliber machinegun, mounted on a jeep, and continued firing. When last seen alive he was standing upright firing into the Jap hordes that were then enveloping him. Some time later his body was found surrounded by enemy he had killed. His valor was consistent with the highest traditions of the service." (Courtesy US Army.)

CHAPTER ONE: MILITARY AND POLITICAL LEADERS

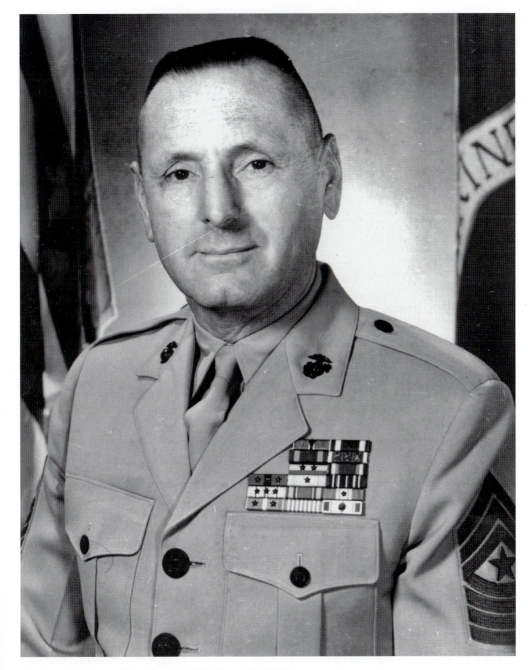

Herbert J. Sweet (October 8, 1919–June 18, 1998)
Sweet grew up in Troy and spent most of his career in the US Marines from 1937 to 1969. He served in the Battle of Iwo Jima and Bougainville in World War II and in the Korean War, winning the Bronze Star, Legion of Merit, Navy Commendation Medal, and four Purple Hearts. He taught naval science at Columbia University after Korea. He was the 4th Sergeant Major of the Marine Corps, which is a unique non-commissioned rank and billet, serving in that post from July 17, 1965 to July 31, 1969. (Courtesy of US Marines.)

LEGENDARY LOCALS

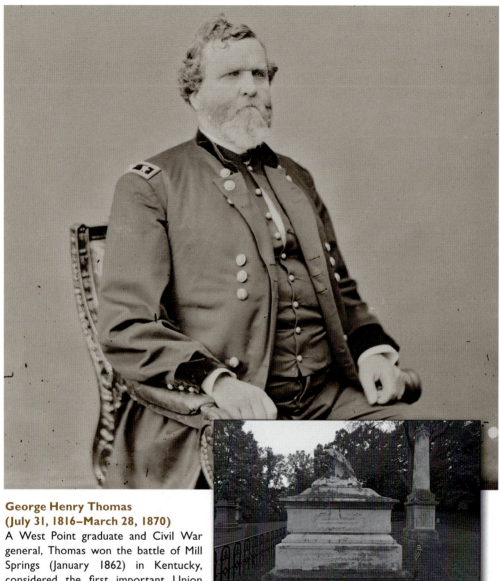

George Henry Thomas (July 31, 1816–March 28, 1870)

A West Point graduate and Civil War general, Thomas won the battle of Mill Springs (January 1862) in Kentucky, considered the first important Union victory in the war. He served under Don Carlos Buell and William Rosecrans, taking part in the Battle of Stones River (January 1863). His most famous battle took place on September 20, 1863, when Rosecrans made a serious tactical blunder at Chickamauga. He opened up a gap in the Union army lines. Rosecrans and his men fled to Chattanooga, but Thomas held his position and earned the nickname "Rock of Chickamauga." Today, this tactic is one of the basic tenets of the US Marines' assault doctrine. Thomas was immediately promoted to brigadier general and succeeded Rosecrans as commander of the Army of Cumberland, serving under Ulysses S. Grant. Thomas joined William Sherman and destroyed the Confederate army in Tennessee. In 1852, he married Frances Lucretia Kellogg of Troy. He was buried with military honors in Troy at Oakwood on April 8, 1870. Pres. Grant, Gen. Sherman, Gen. Hooker, and many other dignitaries were present. Many in the South still consider him a traitor. (Courtesy of Library of Congress.)

CHAPTER ONE: MILITARY AND POLITICAL LEADERS

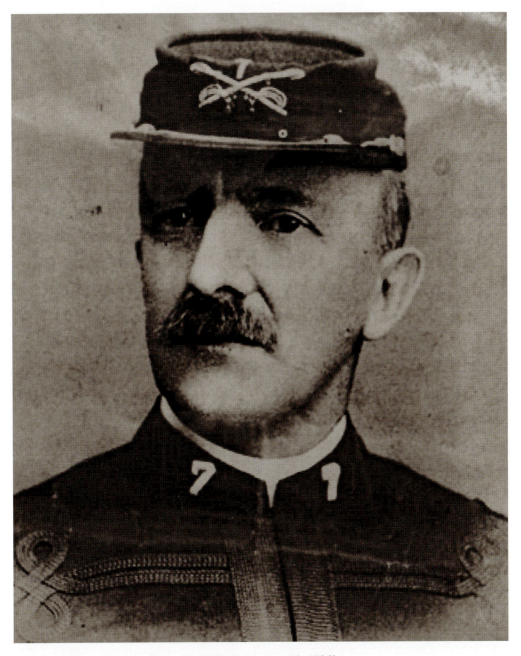

Charles Albert Varnum (June 21, 1849–February 26, 1936)
Varnum was a Troy-born captain of Company B, 7th Cavalry, who won the Medal of Honor in 1897 during America's Indian wars. His citation is for an engagement at White Clay Creek, December 30, 1890. It reads: "While executing an order to withdraw, seeing that a continuance of the movement would expose another troop of his regiment to being cut off and surrounded, he disregarded orders to retire, placed himself in front of his men, led a charge upon the advancing Indians, regained a commanding position that had just been vacated, and thus insured a safe withdrawal of both detachments without further loss." He was Gen. Custer's head of scouts during the Battle of Little Bighorn.

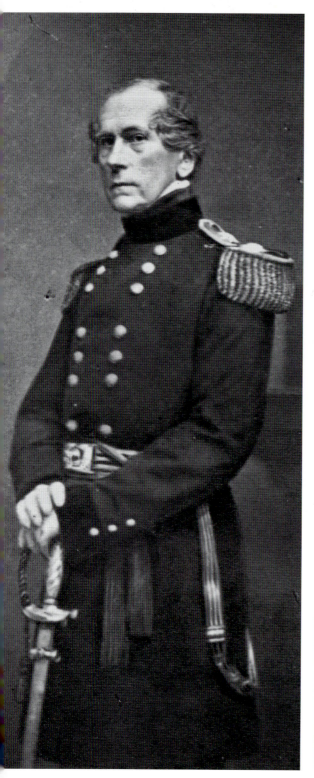

John Wool (February 20, 1784–November 10, 1869)

Wool began his career in the book business, became a lawyer, and then turned military leader, serving in three wars. He was the oldest commander in the Civil War. In 1836, he served in the West removing Cherokees and set up Fort Butler in North Carolina. His attempt to protect the Cherokee got him court-martialed, but he was cleared. He later participated in the Indian wars in Oregon and was disgusted at the way the Native Americans were treated there. He was commander of Fort Monroe in Virginia during the Civil War, where the famous Troy-built USS *Monitor* clashed with the ironclad *Virginia*. He served more than 50 years in the military and was one of Troy's most distinguished residents of the 19th century. (Courtesy of Library of Congress.)

John Wool Monument

The 75-foot-high monument at Oakwood Cemetery can be seen most everywhere in the city.

CHAPTER TWO

Inventors, Businesspeople, and Notables

Troy has spawned many important inventors and business innovators. Some of the first patents in the country were issued to Trojans, and the inventive spirit has never left the city. Many products used in everyday life, including cast-iron stoves, brushes, and bells, were invented and made here. It was a Troy woman and enterprising men who created the collar and cuff industry that dominated the fashion of 19th and early-20th-century America. The iron and steel needed to create western settlements was cast and rolled from numerous Troy foundries and hundreds of mills made products from wire to flour that made their way to stores and homes across the country. Troy has had many notable residents throughout its history.

The Arrow Collar Man (1905–1931)

The Arrow Collar Man was a fictional character who became an iconic image and male sex symbol for selling collars, cuffs, and shirts from the Cluett Peabody Company in Troy. He was used to sell more than 400 different types of detachable collars. The icon was developed by Calkins and Holden, a New York advertising agency, along with Charles Connolly, Cluett's ad man, and well-known illustrator Joseph C. Leyendecker. The Arrow Man was based on Leyendecker's real-life companion Charles A. Beach, whom he met in 1903. Leyendecker was famous for his more than 300 covers of the *Saturday Evening Post* between 1896 and 1950, but his famous Arrow Collar Man was known to receive his own fan mail and marriage proposals at the rate of a thousand a week. The Arrow Collar Man was one of the most successful advertising campaigns in US history, and it was the inspiration for George Kaufman and Marc Connelly's hit two-act play *Helen of Troy, New York*, also starring Helen Ford, who was born in Troy.

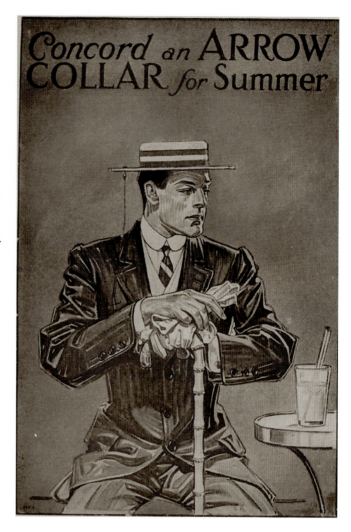

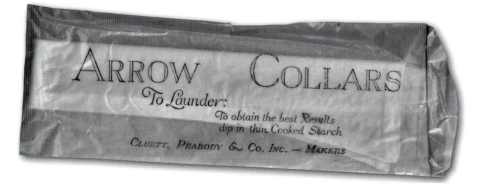

Arrow Collar
An authentic Arrow Collar. Millions of collars and cuffs were made in Troy, the "Collar City."

CHAPTER TWO: INVENTORS, BUSINESSPEOPLE, AND NOTABLES

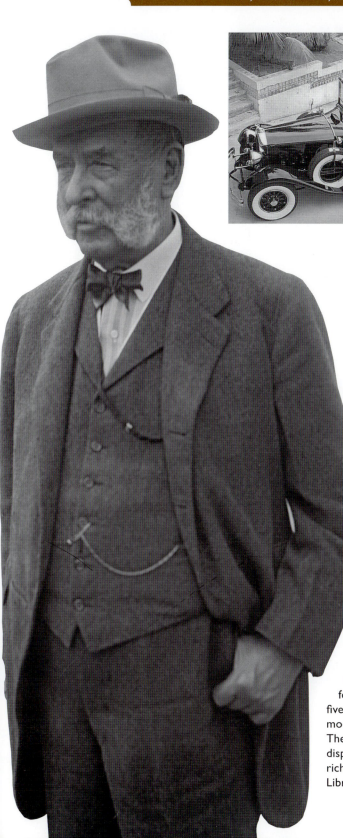

George Fisher Baker (March 27, 1840–May 2, 1931)

The son of a shoe store owner, Baker ended up worth more than $200 million as the result of running or being part owner of a dozen railroads, several banks, and other companies. With John Thompson, he created the First National Bank of the City of New York in 1863 and was its president in 1877 at age 30. He provided a grant of $5 million to start the Harvard Business School. He was so rich that he had a special Pierce Arrow town car, pictured, built by the company in 1929 for his daughter's wedding. It was five inches taller than their regular models, so he could wear his top hat. The car had an intercom and perfume dispensers. He was one of the 10 richest men in America. (Courtesy of Library of Congress.)

LEGENDARY LOCALS

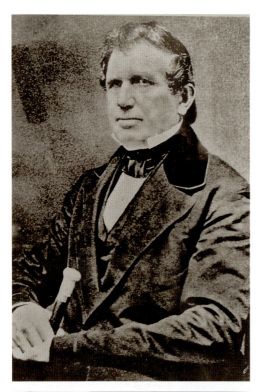

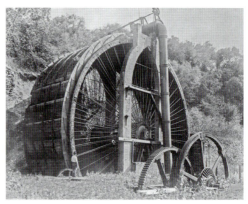

Henry Burden
(April 22, 1791–January 19, 1871)
Burden was a Scottish inventor who created the first automatic horseshoe maker, which became so popular that the Confederate army tried to sneak spies into the factory to steal the design. Most of the horses in the Union army during the Civil War were clad by Burden horseshoes. He created the largest water wheel in the world for his company (pictured). It was called "the Niagara of Water Wheels" by poet Louis Gaylor Clark. It was the blueprint for Rensselaer Polytechnic Institute graduate George Ferris, who built the Ferris wheel. Burden also tried to build steamboats that would have less draft and move faster than existing ones.

Burden's Iron Products
A few of the iron products made by Burden. Burden perfected making horseshoes but also made rail iron, spikes, man hole covers, bolts, and other iron products that were shipped around the world.

Sanford Cluett (1874–May 18, 1968) (RIGHT)
Cluett was a Troy-born cousin of the Cluett family of collar fame. A surveyor as a youth, a medical dropout, and a pioneer in ballistics, he was also an alligator hunter and speaker of the Seminole language. He graduated RPI in 1898 with an engineering degree and while there he invented a bubble sextant used in celestial navigation. Thanks to his inventions, 21st-century Americans have wrinkle-free clothing and can wash clothing many times without it shrinking. The term Sanforized is named for him. A meticulous note taker, he once took notes on a tablecloth, had it notarized, and used it in a lawsuit to prove an idea was his. He entered the clothing business in 1919 at 45 years old. He developed a process to stretch and shrink clothes before cutting to reduce overall shrinkage in washing, and his patent was purchased and used by Cluett Peabody and made available to the entire industry. It was heralded as the most important discovery since the invention of fast dye. When he died, 448 mills in 50 countries were using his process. His other major invention was Clupak, a stretchable tear-resistant paper used in shopping bags, wrapping papers, and even furniture. (Courtesy RCHS.)

CHAPTER TWO: INVENTORS, BUSINESSPEOPLE, AND NOTABLES

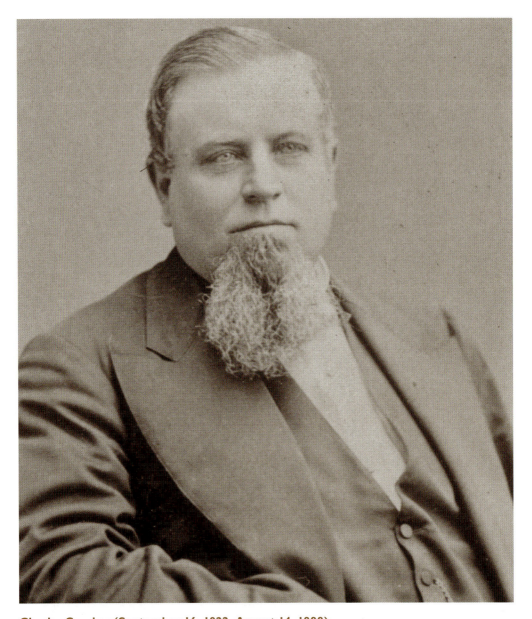

Charles Crocker (September 16, 1822–August 14, 1888)
Crocker was one of four men who founded the Central Pacific Railroad, which became the western part of the First Transcontinental Railroad. Born in Troy, he distributed newspapers at age 12. He began his fortunes by starting his own iron forge in 1845. He was the construction supervisor and president of Charles Crocker & Company, a company spun off from Central Pacific to build the railroad. Having difficulties keeping snow off the tracks, he built $2 million worth (40 miles) of snow sheds to cover the tracks in the Sierra Nevada. He was also responsible for the second transcontinental railroad in 1881 when the Southern Pacific met the Atchison, Topeka, and Santa Fe Railroad. He also controlled Wells Fargo for a short time as president and dabbled in other bank interests. He was a member of the Sacramento city council and was elected to the California state legislature in 1860. (Courtesy of Library of Congress.)

CHAPTER TWO: INVENTORS, BUSINESSPEOPLE, AND NOTABLES

Orsamus Eaton
(April 30, 1794–November 5, 1873)
Eaton was a carriage maker at 2 First Street for 10 years, but took in a partner, Uri Gilbert, in 1830. They began building coach cars for steam railroads, omnibuses, and post coaches on the northeast corner of Albany (Broadway) and Sixth Streets. When a fire destroyed their Troy shops in 1852, they moved to Green Island and began building double-decker train cars (called Monitor roofs) and wagons for the Union army during the Civil War. They produced the first eight-wheeled passenger cars for the Schenectady and Troy Railroad, but were sued for patent infringement by Ross Winans, a railroad inventor and builder. In one year, 1850, they made 150 stagecoaches, 50 omnibuses, 30 passenger cars, and 150 freight cars in their factory on Sixth Street between Albany and Fulton Streets. Those shops were also destroyed by fire and Eaton retired, leaving the firm. Gilbert went on to form another company. Orsamus was the brother of RPI founder Amos Eaton.

Eaton's Gravesite
Eaton was buried at Oakwood Cemetery, and his gravestone overlooks the city he loved. Considering his wealth, his headstone is not as flamboyant as others of his status.

LEGENDARY LOCALS

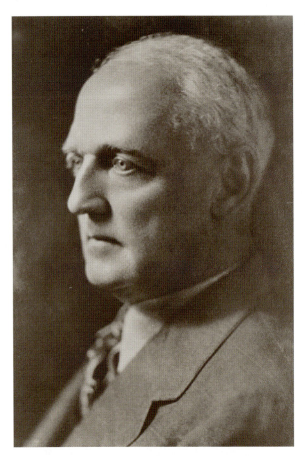

Joseph O. Eaton
(July 28, 1873–May 15, 1949)

Eaton began working for collar maker George P. Ide & Company around 1895, working his way up to manager of the collar department after seven years. He also married George Ide's daughter Edith. He formed the Interstate Shirt and Collar Company and was treasurer there for five years. While in Troy, he met Viggo Torbensen, who patented the first gear-driven rear truck axle. Eaton formed the Torbensen Gear and Axle Company (now the Eaton Corporation) in 1911 and moved to Bloomfield, New Jersey. He moved the company to Cleveland in 1915. Today Eaton Corporation is a major diversified power management company with 2010 sales of $13.7 billion. (Courtesy of Scott R. Schroeder.)

Torbensen Motor Car Company

Eaton's Torbensen Motor Car Company. This small automobile company grew to become one of the largest global technology leaders in power management today. (Courtesy of Scott R. Schroeder.)

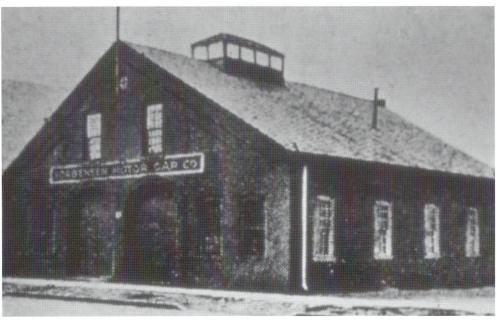

CHAPTER TWO: INVENTORS, BUSINESSPEOPLE, AND NOTABLES

Titus Eddy
(March 1, 1803–February 6, 1875)

Eddy knew the ink business, as his brothers George Washington Eddy and Thomas Jefferson Eddy were owners of the Franklin Ink Works in Waterford, established in 1831. Titus created an ink manufacturing company of his own off Oakwood Avenue in Troy (now Eddy's Lane) and invented a special formula for ink used to print the US currency. He also produced for the US Treasury two special inks, a yellow one for printing gold certificate and green for silver certificates. No one, not even his workers, knew the formula. Eventually his son James continued the government ink contract until 1908, and when he died in 1918 he took the secret ingredients with him. In a sundry civil appropriation bill hearing in 1907 discussing the price of ink, the head of the Bureau of Engraving and Printing, Thomas Sullivan, stated, "Years ago, there was a firm up in Troy, New York and I think they are just as square a firm as ever lived—the firm of Titus Eddy & Sons. They will not sell a pound of their black today under 55 cents under any circumstances, but they have a magnificent black, which has been recognized as a standard black in bank-note printing for 60 years. It has been recognized in the bureau also as a standard of fine black, to my knowledge, for 35 or 36 years." Titus served on the city council from 1839 to 1840 and from 1863 to 1866, and was one of the first directors of the Manufacturer's Bank of Troy. His Glenwood home (pictured) is now offices for public housing.

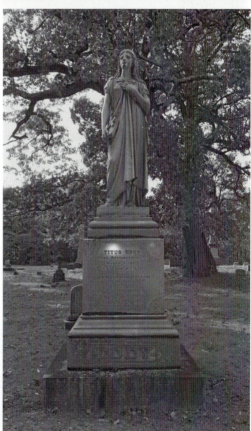

Eddy's Gravestone
Eddy is buried at Oakwood Cemetery. The statue is beautiful, but gives no indication of the impact he made. His son's gravesite has a large quill pen engraved on the stone in honor of his father.

39

LEGENDARY LOCALS

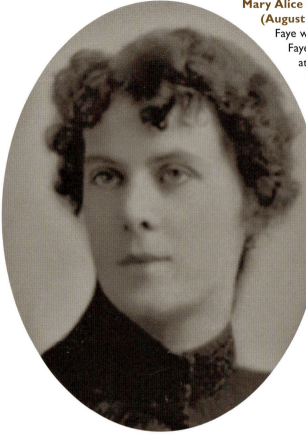

**Mary Alice Fahey (Mame Faye)
(August 15, 1866–May 5, 1943)**
Faye was Troy's most famous madame. Mame Faye was 46 when she opened her "house" at 1725 Sixth Avenue (1906 to 1941) that centered on the railroad station between State and Broadway. The house was only three doors north of the police station, pictured here shortly after it opened in 1924. The area was known as the red light district because the railroaders would hang their lanterns out so crew callers could find them. Even with the police station built in the district, it was known that the police would often be stationed outside the more frequented houses and in return Madame Faye would send over fresh pots of coffee to the patrolmen at the station. When she died, she left her nephew an amount equal to $3.5 million in today's dollars. (Courtesy of RCHS.)

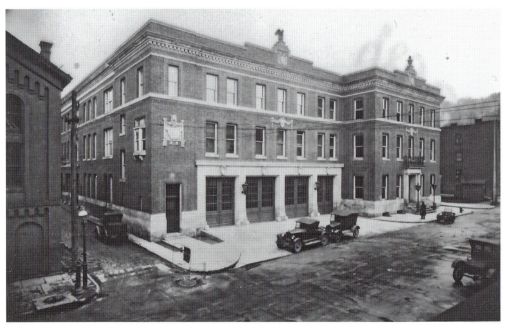

CHAPTER TWO: INVENTORS, BUSINESSPEOPLE, AND NOTABLES

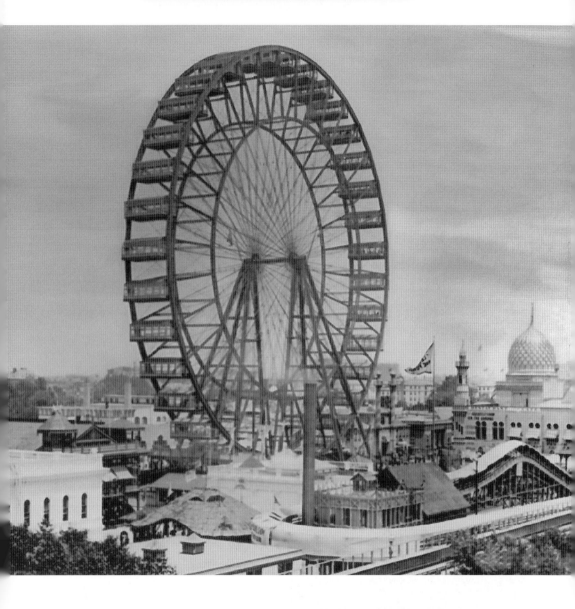

George Washington Gale Ferris Jr. (February 14, 1859–November 22, 1896)
Ferris was a graduate of Rensselaer Polytechnic Institute in 1881 in civil engineering. While a student in Troy, he was inspired by the Burden Iron Wheel, which powered Burden's upper works off Mill Street in South Troy. It had an output of 1,200 horsepower, measured 60 feet in diameter, 22 feet wide, and had 36 buckets. In 1891, the upcoming World's Columbian Exposition in Chicago issued a challenge to all American engineers to invent something that would challenge the Eiffel Tower that graced the 1889 Paris International Exposition. Ferris drew up plans for a rotating "observation" wheel like the Burden Wheel that would hold passengers instead of water. The exposition planners accepted it, hoping that admission to ride it would help pay for the expenses of the fair. The Ferris wheel, like the Burden Iron Wheel, had 36 cars (buckets) holding over 2,000 people on a ride. It is estimated to have had 1.5 million riders during the fair. Today, the Ferris wheel and its clones are still major attractions at amusement parks.

August 14, 1915. AUTOMOBILE TOPICS 25

PIONEER PRODUCES THE HARVARD

New $750 Light Roadster Is Built on Conventional Lines—Light Weight and Narrow Tread Are Special Features.

Under the name of Harvard, the Pioneer Motor Car Co., of Troy, N. Y., is putting forth a light two-passenger roadster that sells complete with electric lighting and starting system for $750, and which, price and general specifications considered, has numerous features that recommend it to attention. The car was designed by H. P. Jones, who is engineer of the Pioneer company, of which Northrup R. Holmes is president and A. L. Johnson secretary.

In a general way the machine is one of those attractive appearing, small cars, that may be said to have resulted indirectly from the cyclecar agitation of a couple of years ago, but in which the outward aspects of conventional design have been seriously and consistently maintained, as have the usages of ordinary mechanical construction for the most part. It weighs under a thousand pounds and has a wood frame reinforced with steel, and quarter-elliptic cantilever springs front and rear, but otherwise is of not unusual build.

By way of power plant the well-known Model 2¾ x 4½-inch four-cylinder block unit power plant is used, together with Raybestos-faced disc clutch and three-speed selective gearset. A Carter carbureter, independent magneto ignition and constant-level splash oiling are used. The wheelbase is 84 inches and the standard tread is 44 inches. Spranger wire wheels, 28 inches in diameter and shod with 3-inch tires are offered, but the purchaser is also given the option of wood wheels, demountable rim equipment also being optional. A further option is granted in the matter of right or left drive, which can be had to suit the purchaser's requirements.

Instruction Book for Willys-Knight Is Very Complete

Uncommonly explicit, as is all Overland literature addressed to the owner, is the new book of "Directions for the Operation, Care and Adjustment" of the new Willys-Knight, Model "84," which has just made its appearance. In the preparation of the book, which runs to 110 pages with many illustrations, the Willys-Overland Co., Toledo, has been at great pains to place the

THE HARVARD ROADSTER SELLING FOR $750 FULLY EQUIPPED

Roadster Body Built First in Clay

Clay modeling was employed in designing the body of the Dodge Brothers roadster, which now is being distributed in increasing numbers from the Detroit factory. When the clay had been fashioned to suit the designer, the bodies themselves were then commenced, the construction being all steel, with no wood frame work. The car seats two, has a roomy baggage compartment in the rear, and weighs 2,150 pounds.

Fort Dodge Firm Handles Stearns-Knight in Whole State of Iowa

The Knight Motors Co., of Fort Dodge, Ia., has been appointed state distributor of Stearns-Knight cars in the state of Iowa. The company is composed of P. J. Tierney and H. J. Hickey. The latter was formerly with the Cadillac sales branch in Fort Dodge, and resigned to become general sales manager for the Knight Motors Co., in charge of the wholesale department.

The terminal board under the left rear seat is continued as before with the exception that five-ampere fuses are now employed, instead of the four-ampere lately. The third-speed shunt is now wound with larger wire to give a slightly higher third speed, while a number of improvements have been made in the controller. The bearings are all of the self-lubricating type in the present construction, and the controller cover is now of pressed metal, while the resistance for the adjustment of the motor brake, together with the motor shunt, has been mounted on the controller base and underneath the cover. Automatic lubrication of the controller drum is effected by means of a felt wick, the length of the drum, that is saturated with sperm oil and so mounted that the contacts wipe across the felt and are thus maintained in proper condition at all times. The felt is now mounted in an insulated casing, to avoid the possibility of electrical leakage.

The same style of motor brake as has been used heretofore is retained, but detailed improvements have been made in several respects. The friction disc is now Raybestos and is mounted on a large diameter screw thread, which enables the friction disc to be adjusted. The first-speed resistance is of new design, consisting of a single coil of heavy wire supported on the frame at each end to afford ample air cooling and at the same time reduce weight. Revision has also been made of the controller mast details, in which connection the ball universal joints have been replaced by adjustable joints of sturdier construction. Another improvement is the introduction of a spring steel connection between these joints, which, while stiff enough for purposes of ordinary operation, is calculated to yield slightly under excessive pressures, such as might be put upon the parts by a nervous operator, whereby the bending or disarrangement of the finer and more delicate parts of the control mechanism is prevented.

purchasers of the new car on a footing of understanding with the machine whereby they shall want for nothing that common sense and "handiness" cannot give.

The fatal assumption that the possessor of one of the new machines is both experienced in the ways of automobiles and super-intelligent, has not been made, and any person of fair ability can quickly grasp from its pages and clear diagrams the essentials of caring for the car and also the very necessary things to be learned in driving, such as rules of the road, attentions peculiar to summer and winter weather conditions, care of tires, and the like. As a constant link between the owner and the courtesies of the Overland service department, it should prove of invaluable assistance.

Sometimes what is intended for praise may be twisted around to have a different meaning. As examples of unfortunate phraseology, an intending customer cites the remark of a salesman that his machine was "a rattling good car," and another to the effect that it was "a fine car—on the level!"

Theodore Fitchfield (June 20, 1890–?)

Fitchfield formed the East Side Garage in Troy with partners in 1915. He was approached by Northrup Holmes to build a car from plans made by Charles Herreshoff, who skipped town on Holmes. His Herreshoff Light Car was also built in Troy in 1914. Fitchfield formed the Pioneer Motor Car Company (soon after called Harvard Pioneer) and built a small four-cylinder car called the Harvard that may have been the first to conceal the spare tire. It was made for the New Zealand market, so it had a right-hand steering wheel. Construction of the cars moved to Hoosick Falls. They sold the business to a Maryland firm that went out of business during the Great Depression. The cars were made from 1915 to 1921. (Courtesy of Royal Feltner.)

CHAPTER TWO: INVENTORS, BUSINESSPEOPLE, AND NOTABLES

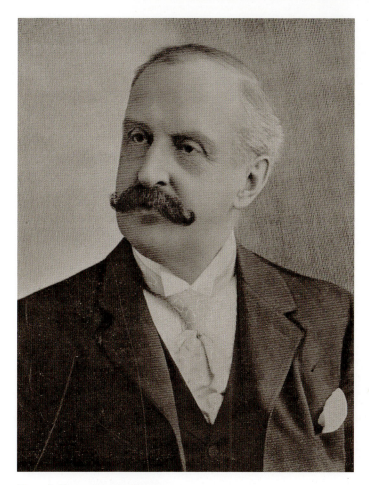

William H. Frear (March 29, 1841–January 2, 1910) Frear began working at the John Flagg merchant store in 1859 as a clerk. After trying his own hand in the business with a fellow named Haverly, by 1869 he had his own place in the Cannon Building called Frear's Cash Bazaar. He was the first to insert a full-page ad in a local newspaper, and his motto "Satisfaction guaranteed or your money cheerfully refunded" hangs on a plaque in the Frears Department Store on the corner of Third and Fulton, now offices for the State of New York. Frear Park is named for him.

Frear's Department Store
The store is pictured in its heyday during the 1950s. Frear's staircase was famous. The main stairs are gone, but the atrium still exists, although the first floor and marble staircase have been modified.

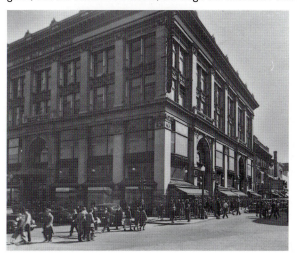
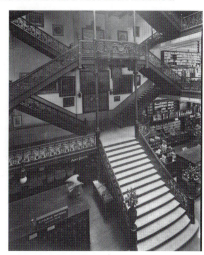

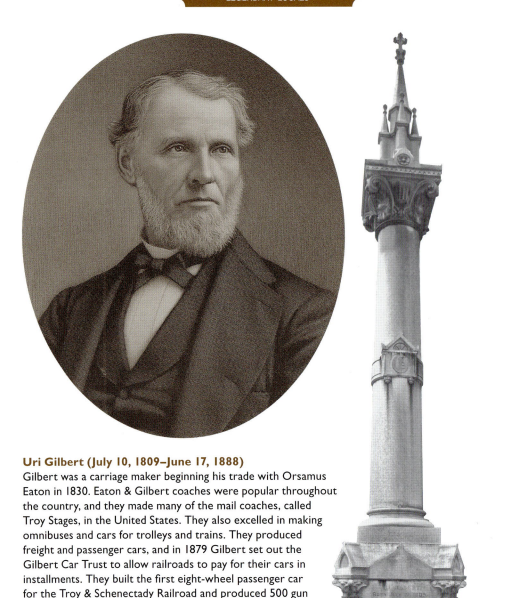

Uri Gilbert (July 10, 1809–June 17, 1888)
Gilbert was a carriage maker beginning his trade with Orsamus Eaton in 1830. Eaton & Gilbert coaches were popular throughout the country, and they made many of the mail coaches, called Troy Stages, in the United States. They also excelled in making omnibuses and cars for trolleys and trains. They produced freight and passenger cars, and in 1879 Gilbert set out the Gilbert Car Trust to allow railroads to pay for their cars in installments. They built the first eight-wheel passenger car for the Troy & Schenectady Railroad and produced 500 gun carriages during the Civil War. They moved to Green Island after the Troy plant was destroyed by fire on October 28, 1852. For several years Gilbert was alderman in the Third Ward and was Troy mayor from 1865 to 1870. Charles Nalle, a runaway slave, worked for Gilbert as a coachman and after being arrested was rescued by Harriet Tubman and other Trojans. Gilbert helped pay for Nalle's freedom. Eaton & Gilbert stopped producing in 1895 a few years after his death.

Gilbert's Gravestone
Gilbert is buried at Oakwood Cemetery and has one of the largest monuments in the cemetery.

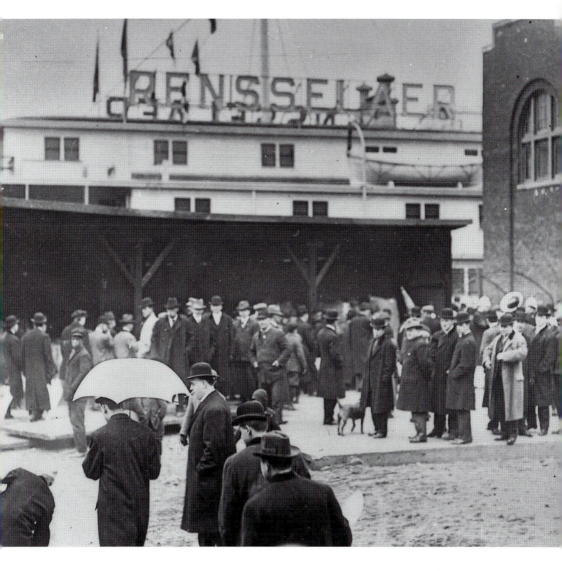

Griffith P. Griffith (1789–1854)

Griffith was the owner of G.P. Griffith & Co and founder of the Troy & Erie Transportation Line in 1827 that had a number of steamboats that plied between New York City and Lake Erie. He owned the *Robert Fulton, Dewitt Clinton, New York*, and the *G.P. Griffith*. He was a trustee of the Troy Orphan Asylum. In 1849, he had at 191 River Street the New York and Troy Tow Boat Line with 48 boats and barges on the Hudson. The steamboat *G.P. Griffith* took part in one of the greatest lake disasters in history when a fire onboard proved disastrous on June 17, 1850. Its captain, Charles Roby, turned the boat to its port side, running to the shore in darkness, fanning the flames, and failing to give an order to abandon the rapidly moving ship. People dove into the waters, some getting caught in the paddle wheels, others drowned from the weight of clothes and money sacks. Some swam the wrong way in the dark. The crew abandoned their posts, and the ship hit a sandbar in eight-foot water. The captain and his family drowned, and many others burned to death on board. In all, 241 people died, and only 37 survived. It was the worst Great Lakes disaster in history at the time. The loss of the *Griffith* was instrumental in bringing about the first public safety laws to govern vessels on America's waterways.

LEGENDARY LOCALS

William E. Gurley
(March 16, 1821–January 11, 1887)

A Troy-born surveyor, Gurley founded one of the oldest surveying manufacturer companies in America. He began his work with Oscar Hanks, bell maker, and in 1845 joined with Jonas H. Phelps to create surveyor equipment. His brother Lewis joined in 1851, and after Phelps sold out his share the firm became known as W. & L.E. Gurley. Their transits, compasses, and surveyors' tools were and still are known for quality and craftsmanship. The firm still exists today as Gurley Precision Instruments and operates out of the same building (pictured). Gurley graduated from RPI in 1839 and later became its president from 1886 to 1887. He also served as a trustee of RPI and Troy Female Seminary (now Emma Willard), was president of the Troy YMCA and National Exchange Bank (1877), and served on the city council from 1860 to 1864 and in the New York State legislature in 1867.

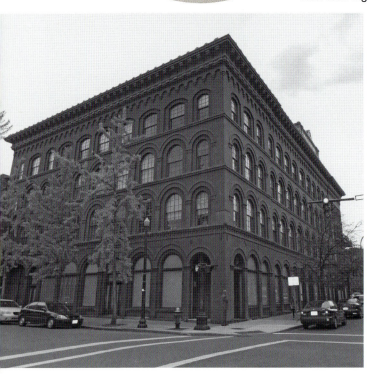

Gurley's Monument
Gurley's monument stands at Oakwood Cemetery.

CHAPTER TWO: INVENTORS, BUSINESSPEOPLE, AND NOTABLES

John Hedley (November 4, 1935–Present)

John is a Troy used car salesman turned developer. For those growing up in Troy during the 1960s, Hedley was synonymous with used Cadillacs, and he sold them for 40 years. His early ambition was to play baseball. He made it to spring training with the Pittsburgh Pirates but was injured and never played in the major leagues. Twenty years ago, he began redeveloping old 19th-century collar and shirt buildings in Troy. His first project was converting the old Cluett Peabody & Son shirt factory at 433 River Street in 1990 into Hadley Park Place, which houses state health workers. That was followed by restoration of the Miller, Hall & Hartwell Shirt & Collar Company, now called Flanigan Square (pictured and named after a local priest, Father Thomas Flanigan) on Hoosick and River that houses more state health workers and those from housing and community renewal. That was followed by the Market Block, a series of five 19th-century commercial buildings at the intersection of River, Fulton, and Third Streets. These have been renovated into a bookstore, restaurants, and retail space. He recently sold the land of his former Cadillac dealership for a new development. (Courtesy of Mark McCarty.)

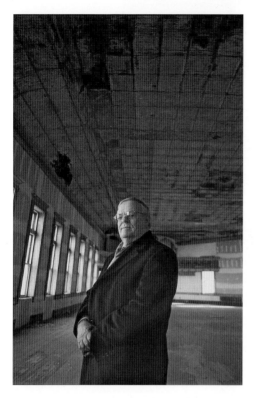

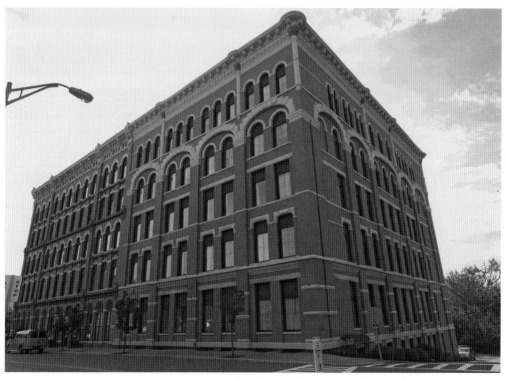

LEGENDARY LOCALS

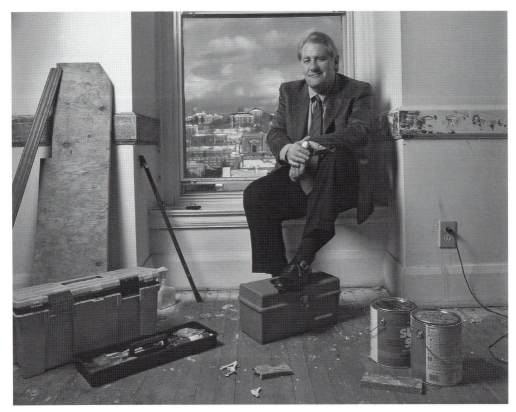

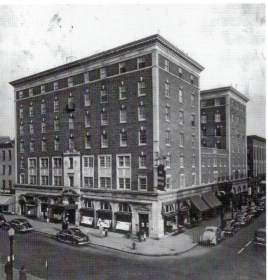

The Hendrick Hudson Hotel in Its Former Days
Restored by Sandy Horowitz, the hotel now houses offices for the State of New York.

Sanford J. "Sandy" Horowitz (August 17, 1945–Present)
A movie producer turned real estate developer, Horowitz's producing credits include seven features from 1973 to 1993 and include science fiction and horror (*The Clones*, *Twisted Nightmare*, *Demon Wind*), documentary (*The Carradines Together*), and drama (*Club Life* starring Tony Curtis). He later entered real estate with shopping malls, and while selling a number of properties in New York City he decided to buy an equal amount. Beginning in 2003, he chose Troy to invest, purchasing several downtown buildings including four landmarks: the Hendrick Hudson Hotel, Cannon Building, former Christian Science building (33 Second Street), and Keenan Building. These landmarks were deteriorating and Horowitz brought them back to life. The Cannon Building now houses long-term residential suites. The hotel houses the state attorney general and a restaurant, while 33 Second Street and the Keenan Building feature offices and restaurants. While some of his history in the city has been controversial, many consider him a hero for saving these iconic buildings. (Courtesy Mark McCarty.)

CHAPTER TWO: INVENTORS, BUSINESSPEOPLE, AND NOTABLES

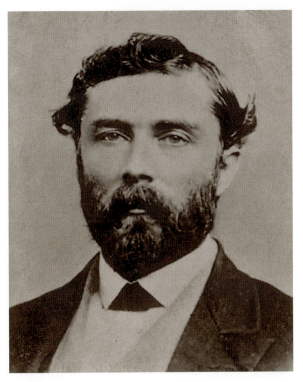

Theodore Dehone Judah (March 4, 1826–November 2, 1863)

Judah was a graduate of Rensselaer Polytechnic Institute and son of an Episcopal priest in Troy. He was the brains and vision behind the construction of the Transcontinental Railroad but never received the credit. As chief engineer of the Central Pacific Railroad he convinced the "Big Four"—Leland Stanford (from Watervliet), Collis P. Huntington, Mark Hopkins, and Charles Crocker (from Troy)—to finance the construction. Judah was successful in getting the US government to authorize the transcontinental railroad by passing the Pacific Railroad Act (1862), but instead of him heading the construction, the Big Four gave it to Troy's Crocker to build, even though it followed Judah's plans. He died of yellow fever crossing the Panama region as he was looking for alternative financing to buy out the Big Four.

American Locomotive

American Locomotive was formed from Schenectady Locomotive Works, which built the *Jupiter*, one of the engines that made the transcontinental connection

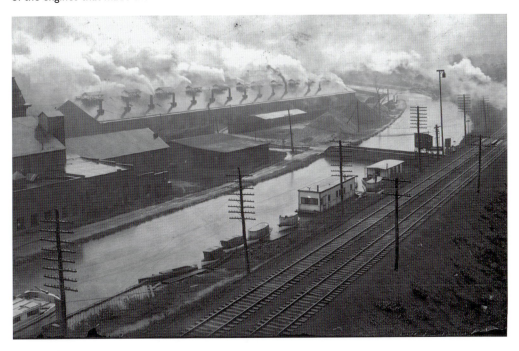

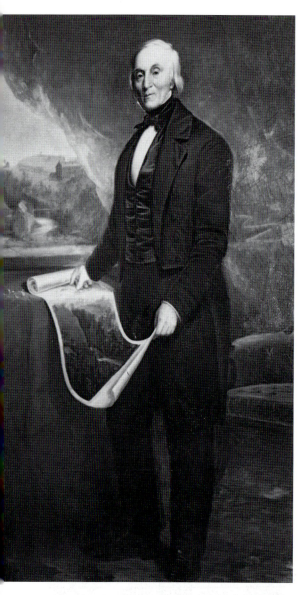

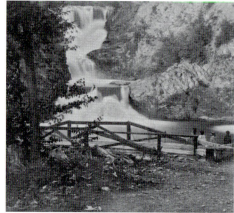

Benjamin Marshall (1782–December 2, 1858)

After obtaining water rights in 1825, Marshall operated a gingham and cotton goods mill in Mount Ida Falls along the Poestenkill off Congress Street. He was one of the first directors of the Commercial Bank of Troy in 1839. In 1840, Marshall harnessed the power of Mount Ida Falls (pictured) by drilling a 600-foot tunnel through solid rock to provide power to his cotton factory and many other mills that soon sprang up in the gorge. By 1845, 320 factory workers were working in the gorge. It wasn't until the 1960s that Manning Paper mill closed for business ending use of the power of the falls. In 1850, he founded Marshall Infirmary not far from the falls, originally for disabled workmen but later to serve the sick people of Troy who could not afford medical aid. The directors paid an annual contribution and were able to recommend one sick person to be cared for free every year. More than 10,000 people were cared for in the infirmary in its time. The county built a home for the insane next to the infirmary. The buildings were razed in recent time for new condominiums. Marshall was also president of the Board of Trustees for Emma Willard School and president of the city-owned Schenectady–Troy Railroad. (Courtesy Rensselaer County Historical Society.)

Marshall's Tunnel

Several mills and foundries tapped into the power of Marshall's tunnel and were in operation up to the 1960s.

CHAPTER TWO: INVENTORS, BUSINESSPEOPLE, AND NOTABLES

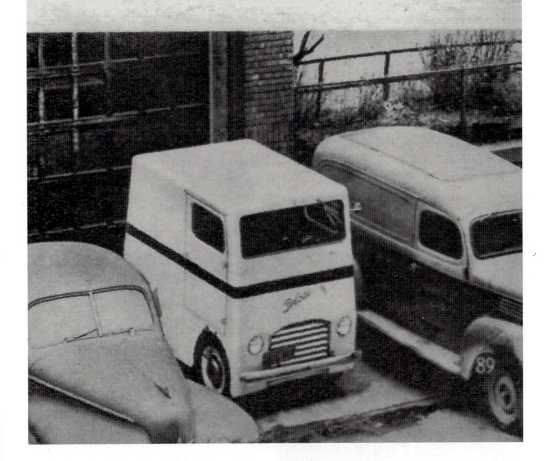

William Patrick McColl (October 26, 1902–October 20, 1991)
McCall was vice president of American Motors at 466 Eighth Street in Troy, New York, not to be confused with the other American Motors. Troy's AMC only lasted from 1946 to 1949 and produced the DELCAR, a small boxlike van that was the first American car with independent suspension on all four wheels. Designed for business use, it flopped. They produced only about a dozen trucks and a couple of station wagons that fit only adults. (Courtesy Dan Strohl.)

Clinton H. Meneely (1839–1923)
Clinton was the youngest of the three sons of Andrew Meneely, who began casting bells in West Troy (Watervliet) in 1826. Clinton opened his Troy foundry after the Civil War when his brothers wouldn't let him enter their partnership in Watervliet. Meneely went into partnership with his brother-in-law George H. Kimberly. They operated as the Meneely & Kimberly Bell Company from 1869 to 1879 (casting their first bell in January 1871), then were called the Clinton H. Meneely Bell Company from 1880 to 1901, and finally the Meneely Bell Company from 1902 to 1951. Thousands of bells made by both companies still ring in many churches around the world. Meneely Bell Company's last bell was cast in April 1951 for St. Martin's College in Olympia, Washington. Some 65,000 bells were cast between the two foundries. Clinton's foundry is famous for making the reproduction of the Liberty Bell after the first one cracked. (Courtesy Dan Meneely.)

Meneely's "Liberty Bell"
Meneely cast the Suffragette "Liberty Bell."

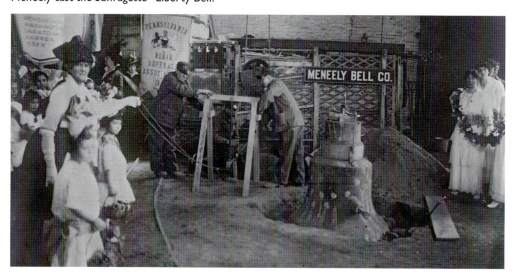

George M. Phelps
(November 10, 1820–May 18, 1888)

Phelps was an important inventor of telegraphs and is considered one of the most important machinists of the 19th century. He began his career making mathematical instruments for his uncle Jonas Phelps. Phelps partnered with William Gurley and began making surveying instruments. At age 30, Phelps started his own machine shop in 1850. Gurley and Phelps's company exists today as Gurley Precision Instruments. Phelps was hired by the Royal E. House Company, which built a working but complicated printing telegraph system. Partnering with his landlord Jarius Dickerman, they created the House's Printing Telegraph Instrument Manufacturing Company at 41 Ferry Street and their product was used throughout the country. Because of its excellent reputation, the American Telegraph Company (ATC) purchased the Phelps and Dickerman Company in 1856 and made George its head. In 1859, he perfected the Phelps Combination Printer. In 1861 he became the head of the ATC's largest factory in Brooklyn, and they also purchased his patents. ATC was finally acquired by Western Union in 1866, and Phelps became the head of their New York City factory. Phelps went on to produce a stock ticker, an electromotor telegraph, and manufactured instruments for Thomas Edison. In 1877, Phelps designed the Western Union Time Ball. Two million New Yorkers set their clocks to a ball on top of Western Union's building at 195 Broadway in New York City, as shown in the woodcut. The ball dropped precisely at noon and remained operational until 1912. The Smithsonian states that Phelps developed what became the standard printing telegraph in America. (Courtesy John Casale.)

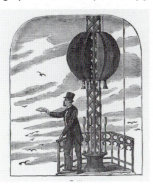

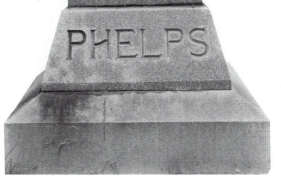

Phelps's Grave
Phelps is buried at Oakwood Cemetery. From this unadorned headstone, one would never guess that its inhabitants had such an impact on 19th-century American life.

The United Shirt and Collar Company Building
The building spans an entire city block and still houses companies that make clothes.

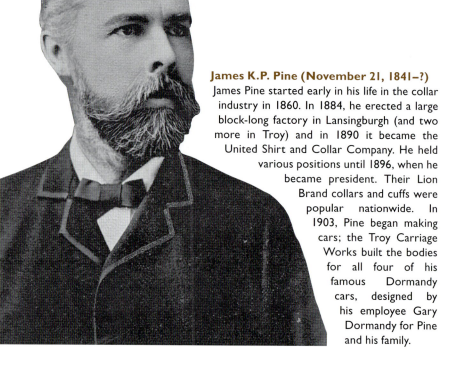

James K.P. Pine (November 21, 1841–?)
James Pine started early in his life in the collar industry in 1860. In 1884, he erected a large block-long factory in Lansingburgh (and two more in Troy) and in 1890 it became the United Shirt and Collar Company. He held various positions until 1896, when he became president. Their Lion Brand collars and cuffs were popular nationwide. In 1903, Pine began making cars; the Troy Carriage Works built the bodies for all four of his famous Dormandy cars, designed by his employee Gary Dormandy for Pine and his family.

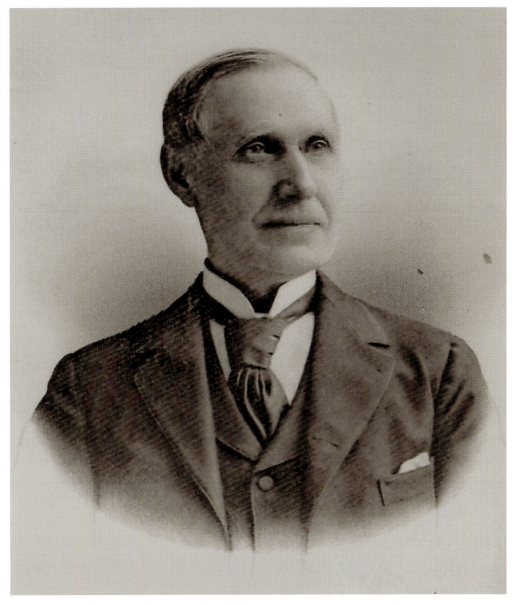

Russell Sage (August 4, 1816–July 22, 1906)

Sage began his career as an errand boy at his brother's grocery store and later became part owner of a grocery and wholesale store for several years. He was elected to the city council in 1841 and in 1848 became treasurer of Rensselaer County. Elected to Congress in 1853, he argued that the government should purchase Mount Vernon. He later went to Wall Street and amassed a fortune. He was associated with Jay Gould and railroads and the Western Union Company, where he served as a director. He married Olivia Slocum, his second wife, in 1869. Sage was controversial, so much so that a man named Henry Norcross made an assassination attempt on him in 1891. Norcross carried a bag of dynamite to Sage's New York office. Sage was hurt in the explosion but survived; Norcross was killed. Olivia used much of her $70 million inheritance to further the education of women, using part of Sage's riches to start the all-female Russell Sage College.

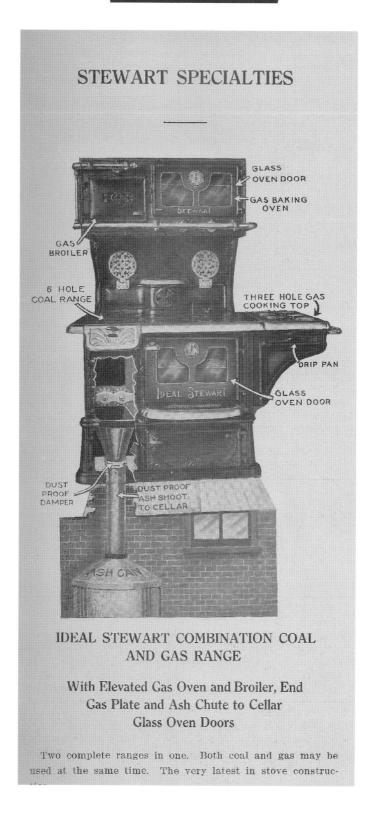

Philo Penfield Stewart
(July 6, 1798–December 13, 1868)

Stewart was a cast-iron stove designer and religious zealot. He joined the American Missionary board and was a missionary to the Choctaw Indians. While preaching, he ran into John Jay Shipherd, a minister and former schoolmate of Stewart's, in 1832. They founded Oberlin Collegiate Institute (now Oberlin College) in Ohio in 1833. It was the first college to include African Americans and both sexes in an integrated educational program. Stewart came to Troy and began designing and making cast-iron stoves with his many improvements. The company was known as Stewart Stoves, and the stoves were made by Fuller, Warren and Company in their Clinton Foundry in South Troy; 90,000 stoves were made. The catalogue pictured shows Stewart's stoves for sale.

John Taylor

Taylor was a draftsman for the Gilbert Car Works and designed a small power truck for small streetcars, but when Gilbert went out of business Taylor eventually created his own company, the Taylor Electric Truck company in 1889. Taylor made electric trucks for companies like the Troy and Lansingburgh Street Railway. The *New York Times* listed the company as incorporating on February 4, 1903 and listed William F. Gurley and A Louise Gurley from the well-known Gurley manufacturers of civil engineering and surveyor instruments as directors. Taylor was president. Taylor also had a patent for a car brake. The company was incorporated to manufacture railway and steel cars, car trucks, wheels, and car brakes with an initial capital of $75,000.

Eliza Waters and George Waters (?–1904)

Eliza Waters, originally a druggist, and his son opened a factory at 303 River Street and began making paper boxes. His teenage son George, pictured after a masquerade party in 1867, borrowed a mask and made a paper replica of it using paper and paste from his father's factory. He and his father then used the same process varnishing and gluing long sheets of paper together to form paper canoes. They were so strong that one year after the first Waters paper boat was constructed, his paper racing hulls won 14 water races, then 26 races the following year. By 1875, they were producing more than 45 different racing shells, rowboats, and canoes, and the *New York Daily Graphic* declared that they had the largest boat factory in the United States. Nathaniel Holmes Bishop began a trip from Quebec to the Gulf Coast of Florida in 1874 using a conventional wooden canoe. When he reached Troy, he ordered a Waters paper boat, and abandoned his wooden one. He wrote a popular book about his exploits called *Voyage of the Paper Canoe*. In 1878, the Waters built a paper observatory dome 29 feet in diameter for the newly erected Proudfit Observatory at RPI. The paper boat industry disappeared when George and Eliza died in 1902 and 1904. Only three Waters paper boats are known to survive. (Courtesy Brian Douglas.)

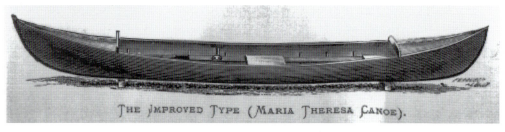

Voyage of the Paper Canoe
This is the paper canoe that Bishop used to sail for his book.

John F. Winslow (1810–1892)
Winslow, a descendant from *Mayflower* stock, was an iron magnate and president of Rensselaer Polytechnic Institute (1865–1868). He partnered with Albany's Erastus Corning in 1837 and created the Rensselaer Iron Works and Albany Iron Works, at one time producing the most iron in the United States. In 1863, they obtained the rights to the Bessemer Steel process and produced the first Bessemer Steel in 1865. Winslow partnered with John Griswold, who financed the construction of the USS *Monitor*. Winslow and Griswold's iron works produced hull plates and bolts for the ironclad. Griswold and Winslow met with President Lincoln to promote the construction of the *Monitor*. Like Griswold, Winslow personally bankrolled his portion of building the *Monitor*. (Courtesy of Library of Congress.)

CHAPTER TWO: INVENTORS, BUSINESSPEOPLE, AND NOTABLES

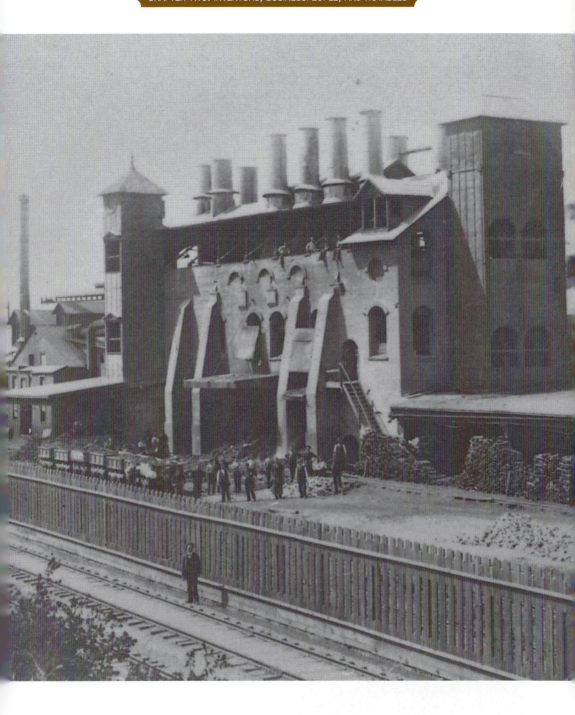

Bessemer Steel Company
The first Bessemer Steel Company in Troy. Holy designed this company completely modifying it to his own specifications and improving on the original British design. Within a decade, there would be 10 more Bessemer plants in the country.

Garnet Douglass Baltimore (April 15, 1859–June 12, 1946)
Baltimore was the grandson of a black slave who escaped to Troy after the Revolution. Garnet's father was a barber in Troy, and he was named for Henry Highland Garnet and Frederick Douglass, two noted black abolitionists. Garnet was the first African American to graduate with a degree in civil engineering at Rensselaer Polytechnic Institute. After years in bridge, railroad, and canal work, he designed the infamous Forest Park Cemetery in Troy (reported to be haunted) and in 1903 designed Prospect Park on Mount Ida, formerly private lands owned by two wealthy Trojans. Prospect Park is still Troy's most popular public park. Originally including fountains, observation towers, gazebos, and winding roads, the park has fallen on tough times but volunteer citizens have been attempting to resurrect the beauty of Baltimore's creation.

Baltimore's Gravesite
Baltimore is interred at Oakwood Cemetery.

Harriet Butler
Butler is the unsung hero of one of the most famous Christmas poems of all time, "Twas the Night Before Christmas." After hearing it read by author Clement Moore to his kids, Butler, who was daughter of the rector of St Paul's Church in Troy (and friend of Moore), asked Moore for a copy. She gave it to the editor of the *Troy Sentinel* and on December 23, 1823, it was published for the first time. Butler was a founding member of the Ladies Association of the City of Troy in 1817. (Courtesy Library of Congress.)

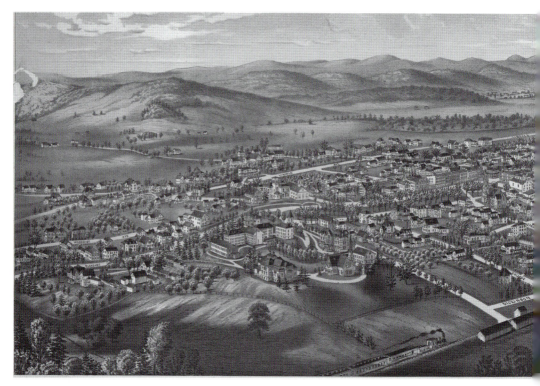

Lucien Rinaldo Burleigh (1853–1923)
Burleigh was a mapmaker who produced a type of map called "Birds-Eye Views" or "Panoramas" that became widely popular in the United States during the 19th century. Often thought of as "Balloon" shots, these maps showed a village, city, or urban area from an oblique view with individual buildings, streets, and landforms in perspective. Preparing a panoramic map wasn't easy. The artist or artists walked down every street sketching every building, tree, or other feature such as hills or streams to present a complete and accurate view as though seen from an elevation up to 3,000 feet. Burleigh originally worked in Milwaukee in 1875 and for H.H. Rowley in Hartford in 1879 perfecting his drawing. Burleigh lived in Lansingburgh, but had his office at 361 River Street in Franklin Square. Originally listed as a civil engineer, by 1886 he was promoting himself as a lithographer under the Burleigh Lithographing Company at 86 Congress Street and published 34 city views that year. His most productive years were 1886 to 1890, but he was still producing as late as 1892. He had a near monopoly on producing views of New York State cities and areas. During the 1880s, Burleigh's views of New York and New England were very popular. The Library of Congress has 163 Burleigh panoramic city plans, including this panoramic of Amherst, Massachusetts. Of all the panoramic artists of the time, Burleigh ranks fifth in the number of views (228), beaten only by T.M. Folwer (426), O.H. Bailey (374), J.J. Stoner (314), and Albert Ruger (254).

CHAPTER TWO: INVENTORS, BUSINESSPEOPLE, AND NOTABLES

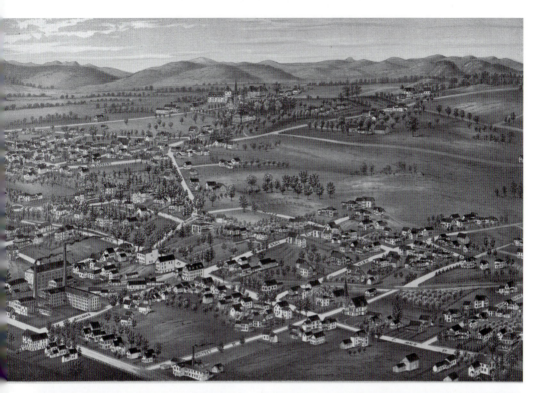

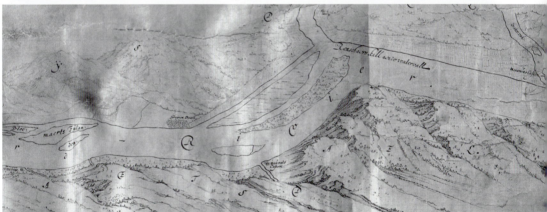

Thomas Chambers (?–April 8, 1694)
Chambers was the first European to settle on what is Troy, leasing land from the patroon on September 7, 1646, for a five-year period on acreage that was located between the Poestenkill and Wynantskill from 1647 to 1654. Barentz Wemp leased part of his farm after Chambers moved to Kingston (Esopus) for a sawmill. Wemp's nickname Poest is where Poestenkill gets its name. Chambers, who was a carpenter and had the nickname "Clabbordt" or Clapboard Man, is believed to be the first to introduce the use of clapboards for house construction. He moved in 1652 and founded Esopus (Kingston), first as a farmer then justice of the peace. Chambers helped stockade the village of Kingston and was wounded in the Esopus Wars in 1658. His estate was known as Manor of Fox Hall and he was buried there. (Courtesy Marieke Leeverink.)

Marcus F. Cummings (March 11, 1836–September 1, 1905)
Cummings was a Troy architect and one of the most prolific in the Capital District region between 1862 and 1880. He came to Troy after the 1862 fire and established himself in the area of commercial, civil, institutional, and residential designs. His Troy buildings include the National State Bank Building, Ilium Building, *Troy Times* Building, Troy City Hall (pictured), Troy High School, Troy Court House, Rensselaer County Courthouse, and the Mount Ida Presbyterian Church. He published two pattern books in 1865 and 1873. Cummings worked with former Trojan and boxer John Morrissey to build his casino in Saratoga Springs in 1867. Marcus retired in 1891. His son and partner Frederick, an RPI graduate, continued building similar projects after his death. (Courtesy of Library of Congress.)

CHAPTER TWO: INVENTORS, BUSINESSPEOPLE, AND NOTABLES

John Daly (1838–April 26, 1906)
Daly was a Troy-born gambler and mobster who was associated with Troy's heavyweight boxer and gambler John Morrissey. He was one of the most successful gamblers in New York and practiced his trade for over 30 years in Manhattan. As a youngster, he spent a great deal of time in Morrissey's gambling houses in Troy, becoming his protégé. Daly was the owner of John Daly's, one of the more popular clubs in New York City. He owned and raced horses, booked bets on them, and hung out with other gamblers and mobsters. His payoffs to New York City cops were revealed in the Lexow Committee Investigations in 1894 and 1895. His *New York Times* obituary called him "one of the most prosperous of his calling." He was buried in Troy.

Canfield Casino
The Canfield Casino, shown here in 1901, was opened by Daly's mentor John Morrissey in 1870 but was closed by reformers in 1907. It is now the Saratoga Springs History Museum. (Courtesy Library of Congress.)

65

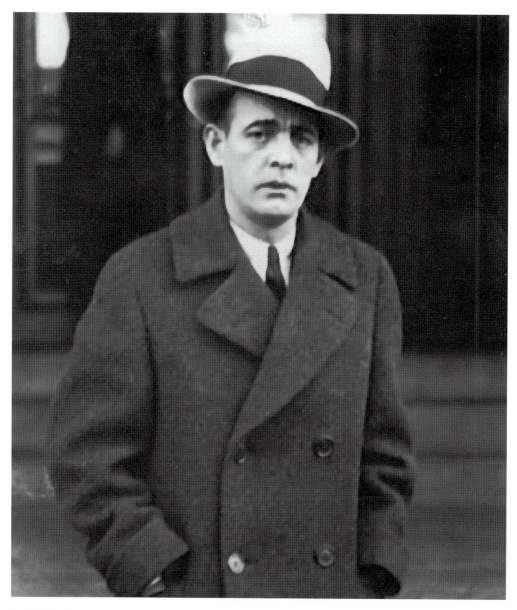

Jack "Legs" Diamond (July 10, 1897–December 18, 1931)
Diamond started a life of crime while still a teenager in Brooklyn. Legs began working for big-time boss Arnold Rothstein and Jacob "Little Augie" Orgen, who was eventually murdered in an attack that also wounded Diamond. He started his own bootlegging business and moved to the Catskills when the city of New York became too dangerous for him (he was shot twice more). It seemed that Legs Diamond could not be killed, and boss man Dutch Shultz once asked, "Ain't there nobody that can shoot this guy so he don't bounce back?" Legs was a frequent visitor to the Kenmore Room in Albany and the Boradaille in Troy. It is rumored that he owned several speakeasies in Troy. After being acquitted of kidnapping charges in the Troy courthouse, he celebrated in Albany and was killed in a boardinghouse on Dove Street. No one knows if it was the Albany police or other gangsters who did it. (Courtesy Library of Congress.)

CHAPTER TWO: INVENTORS, BUSINESSPEOPLE, AND NOTABLES

Carl Erickson (March 17, 1942–Present)
Troy native Carl Erickson is a one-man preservation company. Since the early 1970s, Carl has been purchasing run-down Troy buildings and restoring them singlehandedly. He studied at the Pratt Institute for industrial design, joined the Peace Corps, and was drafted and served his country in Korea in 1970. Carl became an exhibit designer at the New York State Museum until he retired. He has restored 116 Third Street, a three-story 1880s-vintage brick house, the 1835 Elias Ross house at 110 Third Street, the façade on an 1830s row house at 112 First Street, an 1895 Queen Anne-style house at 114 Washington Street, and many other buildings. He now lives in a Federal-style wooden structure known as the "Pumpkin House," which he also restored.

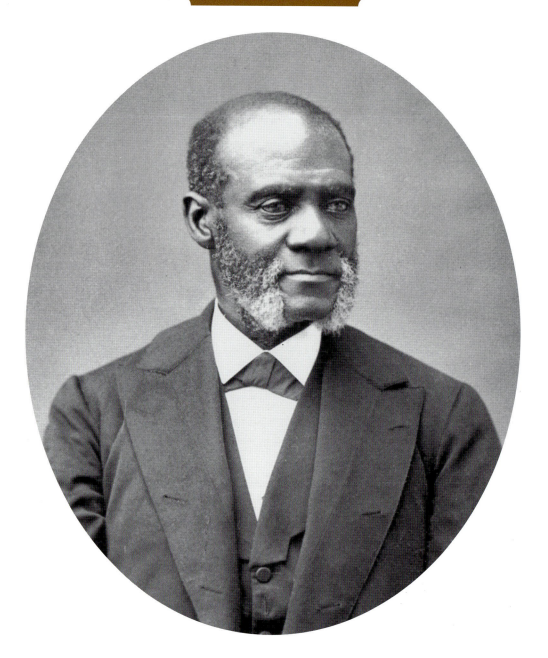

Henry Highland Garnet (December 23, 1815–February 13, 1882)
Garnet was an African American preacher whose fiery rhetoric against slavery was well known around the country. He was pastor of the Liberty Street Presbyterian Church on Liberty Street between Third and Fourth Streets near Troy's Washington Park from 1864 until 1866. He delivered a "Call to Rebellion" at the National Negro Convention in Buffalo, New York, in 1843, suggesting that African Americans resist slavery by mean of armed rebellion. He became the first black minister to address the House of Representatives, on February 12, 1865. At the invitation of the House chaplain William Henry Channing, Garnet spoke about the House's approval of the 13th Amendment abolishing slavery. Garnet was a firm believer in blacks taking control of their own destiny.

CHAPTER TWO: INVENTORS, BUSINESSPEOPLE, AND NOTABLES

Peter Havermans (March 23, 1806–July 22, 1897)
Born in Holland, Havermans was a Catholic priest who worked tirelessly for all citizens of Troy in the 19th century. He came to Troy in 1842 to oversee St. Peter's Church. He first built a Sunday school, then St. Mary's Church at the corner of Washington and Third Streets, authorized on May 30, 1843, and opened on August 15, 1844. West Troy's Meneely cast the bell and W.L. Gurley made the clock. He then led the erection of St. Joseph's Church in South Troy in 1847. He followed that up by bringing the Sisters of Charity to the city, erecting a school, and bringing in the Christian Brothers. In the draft riots of 1863, Havermans kept angry mobs from destroying the *Troy Times* Building, Martin Townsend's home, and the black Presbyterian Church on Liberty Street. He was also partially responsible for the erection of a day school, an orphan asylum, and the Troy Hospital. In 1862, he created the St. Joseph's Provincial Seminary to educate those of the faith. When he died at age 101, he was the oldest living Catholic priest in America. (Courtesy John Diefenderfer.)

Abraham Jacob Lansing (1720–July 11, 1759)
Lansing was the founder of Lansingburgh and purchased the land for 300 pounds from Robert Wendell in June of 1763. It was known as Stone Arabia. In 1771, he had it laid out in streets. It was often referred to as "New City," in contrast to Albany or "Old City." It was a thriving mercantile village when Troy was finally laid out in lots in 1789. In 1900, it was forcibly annexed into the city of Troy. (Courtesy John Wolcott.)

Art Ginsburg (?–Present) (RIGHT)
The TV chef better known as Mr. Food, Ginsburg is the son of a butcher and a graduate of Troy High School. Ginsburg worked in his father's butcher shops on River Street. Also trained as a butcher, he started cooking as a young kid. He started his own catering service after he couldn't afford to hire one for his son's wedding. He started his career as a TV chef as a guest on *Coffee Break*, a local morning talk show on what is now WNYT-13. Ginsburg began his own cooking show in 1975, moving eventually to WRGB, the first and oldest television station in the world, where it still plays. His 90-second segments were a hit locally, and he developed the now familiar "quick & easy cooking." His cooking spots are now syndicated nationally, and he is the author of over 50 cookbooks including three specifically for people with diabetes. His trademark slogan is "ooh it's so good." What started out as a local cooking show now has four million daily viewers nationwide. (Courtesy Rocky Sawyer.)

CHAPTER TWO: INVENTORS, BUSINESSPEOPLE, AND NOTABLES

Hannah Lord Montague (1794–1878)

Hannah was the wife of shoemaker Orlando Montague. She became tired of washing her husband's shirts every day because only the collars were dirty. Sometime in 1827, she decided to cut off a collar, wash it, and sew it back on. The first detachable collar was made at her home at 139 Third Street (pictured). While another person first capitalized on her idea, she is credited for inventing the collar industry in which Troy excelled. Without her moment of inspiration, Troy would not have become known as "The Collar City" during the 19th and early 20th centuries. Her husband, the first person to wear a detachable collar, began his own collar factory with business partner Austin Granger in 1834. The Montague & Granger collar factory began at 222 River Street and developed the "Bishop" collar, an upright modification of the turn-down collar. Besides collars, they manufactured "dickeys" (detached shirt bosoms), and separate cuffs. More than 15,000 people worked in the industry in Troy and most were women. Ninety percent of American men wore a Troy-made collar. At the turn of the 20th century, there were 26 collar and cuff makers and 38 laundries in the city. By 1980, there were none.

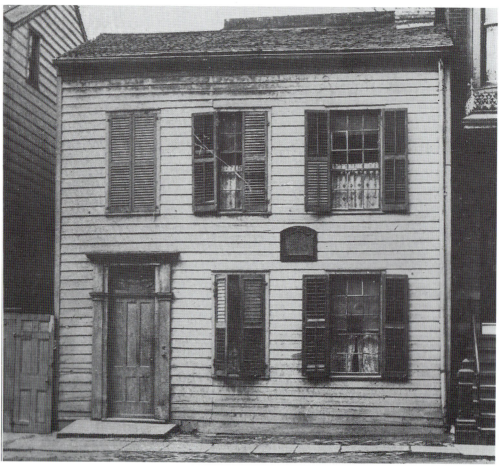

CHAPTER TWO: INVENTORS, BUSINESSPEOPLE, AND NOTABLES

Kate Mullany (1845–August 17, 1906)
Mullany was an Irish immigrant and 19-year-old labor leader for women in Troy who created the first sustainable female collar union in America in 1864. She formed the Collar Laundry Union with fellow workers Sarah McQuillan and Esther Keegan. After watching the actions of the local iron moulders union, Kate decided that women should get paid a fair wage for the hard work they did (they used hot irons, boiling water, and caustic chemicals) and led her first strike on February 23, 1864, and several more after that before the collar bosses consolidated their efforts to put her union out of business. The union lasted more than five years. She created one of the first cooperatives and was the first woman elected to the National Labor Union. Her house at 250 Eighth Street (pictured) became a National Historic Landmark in 1988. She finally received a headstone in her burial plot when a local labor group raised money for a Celtic cross on September 8, 1999.

Charles Nalle (1821–July 13, 1875) (LEFT)
Nalle was a fugitive slave from Virginia who came to Troy and worked for Uri Gilbert, maker of coaches, in 1858. When he revealed his past to a local lawyer, the lawyer turned him in, and he was arrested on April 27, 1860, under the Fugitive Slave Act of 1850. His owner, actually his brother, sent an agent to claim him in Troy, but Troy's citizens rescued him, assisted by Harriet Tubman, who was in the city at the time. He was recaptured, then escaped again and was brought by protectors to the Pine Barrens in Niskayuna for hiding. His freedom was eventually purchased by Uri Gilbert and others, and he lived out his remaining life in Troy. This photograph shows the interior of the jail from which Nalle was rescued.

C. Howard Nash (1916–1979)
Nash was a grandson of Titus Eddy, the manufacturer of ink used for printing US currency in the 19th century. Nash was a member and director of the Taconic Hiking Club, and a member of the hiking club Troy Forty-Sixers (today The Adirondack Forty-Sixers). Within two years, he climbed all 46 peaks in the Adirondack Mountains that were 4,000 feet above sea level or higher, setting the record for that time. (Courtesy of the New York State Library, Manuscripts and Special Collections, C. Howard Nash Collection SC19469 Box 2, Folder 30.)

George R. Poulton (1828–1867)
Poulton was famous for his melody "Aura Lee," which poet William Fosdick wrote lyrics for and Elvis Presley turned into "Love Me Tender," one of his big hits. Poulton's rendition was a popular Civil War song and was often sung by cadets at West Point. He was tarred and feathered for having an affair with one of his young students and died young at 38.

"Aura Lee"
The words and sheet music to "Aura Lee." Note the mis-spelling of Lee. (Courtesy of Wikipedia.)

Deborah Powers (August 5, 1790–May 28, 1891) (RIGHT)
Powers was a businesswoman from Lansingburgh who made a major impact on that village before it was swallowed up by the city of Troy in 1900. Deborah Ball married William Powers, a schoolteacher in the Burgh, but after marriage they turned to making oil cloth and they both had a large factory in 1828. The following year William was burned to death making varnish, and while Deborah was also burned, she survived to raise her two sons and become an economic force in her village. She continued the oil cloth business, taking in her sons as partners. D. Powers & Sons created a private bank and was the only bank in Troy until 1890. After retiring from business, she took up social causes and supported the local school (the Powers School), built the Powers Opera House, donated a park (Powers Park), and in 1883 built the Deborah Power Home for Old Ladies. She lived to be a century old. Her son Albert became a trustee of RPI and was acting president in 1887 and 1888. He was the uncle of Sidney Powers (1890–1932) who became a leading geologist of the time.

CHAPTER TWO: INVENTORS, BUSINESSPEOPLE, AND NOTABLES

Bartholomew "Bat" Shea (February 5, 1871–February 11, 1896)

"Bat" Shea was convicted of killing iron foundry man Robert Ross on March 6, 1894, during an election riot in the city's 13th Ward. He was hired to keep Republicans from voting, so a Democratic saloonkeeper would win. Ross's brother William was also shot by Shea's partner, John McGough, but survived. Shea was electrocuted for the crime, but his partner John McGough admitted later that he killed Ross. McGough received 20 years. There were numerous unsuccessful efforts to save Shea from execution. His last words to a priest were "I am innocent, Father, innocent." Thousands attended his funeral. The photos show the polling house in which Shea killed Robert Ross, as it was at the time of the shooting (below) and as it is today (bottom).

CHAPTER TWO: INVENTORS, BUSINESSPEOPLE, AND NOTABLES

Horatio Gates Spafford Sr. (1778–1832)
Spafford Senior was a lawyer, inventor, and writer. In 1805, he had a patent for an improved fireplace, and began writing to Thomas Jefferson about the properties of iron in 1800. Some believe he originally invented what is known now as the Bessemer Steel process when he read a paper "Cursory observations on the art of making Iron and Steel" in 1816. Spafford's *Gazetteer of the State of New York* (1813) is still regarded as an important reference tool. He died of cholera. (Courtesy Library of Congress.)

Horatio Gates Spafford Jr. (October 20, 1828–October 16, 1888) (RIGHT)
Spafford Junior was born in Lansingburgh and was also a well-known lawyer who lived in Chicago during the disastrous fire of 1871. He and his family decided to go to Europe two years later on the ocean vessel SS *Ville de Havre*. While waiting to sail, Horatio had to return to work, and his wife and girls left without him. On November 21, 1873, the *Ville de Havre* was rammed by a British ship, the *Lochearn*, and his four children drowned. His wife Anna was found unconscious floating on a log. While passing over the spot where his children drowned, he wrote a hymn, "It Is Well with My Soul," in honor of his children. The hymn is still sung today. He died of malaria. (Courtesy of Library of Congress.)

Dirk Vanderheyden (?–October 14, 1738)

Dirk was a "Tapper" (tavern keeper) in Rensselaerwyck and "Father of Troy." He purchased a large farm from Pieter Pieterse Van Woggelum that extended from the Poestenkill to the Piscawenkill in Lubberdes Land (Troy) on December 15, 1720. It was this land that was first divided into three farms for his three sons and it was their sons (Dirk's grandsons) that portioned their lands into building lots that eventually became the city of Troy. Until 1789, Troy was known as "Vanderheyden."

Henrietta Robinson (?–May 15, 1905)

Henrietta is better known as the Veiled Murderess; she was convicted of poisoning two Irish beer drinkers, Timothy Flanagan and Catherine Lubee, in March 1853. Her real name was never known, although the *New York Times* claimed she was Charlotte Wood, a former Emma Willard student (the school denied any connection). The mistress of politician John Cotton Mather, she claimed her innocence and wore a heavy veil even in jail and at the sensational trial. She was found guilty in 1854 but escaped hanging and lived out her life in jail. During her final years at the Mattawan Hospital for the Criminally Insane, she spent many hours making lace, which she wore. Several books have been written about the trial.

CHAPTER THREE

Scientists, Educators, and Writers

Troy is the birthplace of the study of American geology, which began when Amos Eaton founded Rensselaer Polytechnic Institute in 1824. His influence in 19th-century geology has never been equaled. Telegrapher Silas Watson Ford made important discoveries in the field of Cambrian geology. One of Eaton's graduate students, Douglass Houghton, became the first state geologist for Michigan. It was Emma Willard who believed women could learn the same topics as men, and her Troy Female Seminary was one of the first all-female schools to prove it. Lou Ismay believed that children should have their own museum and directed one of the first in the country. Writers such as Herman Melville, Richard Selzer, and poet Dick Allen put words to experiences that will last forever. Their contributions have had lasting effects on our knowledge and appreciation of the world around us.

Dick Allen (August 8, 1939–Present)
Allen has written seven books of poetry. In high school, he was a summer counselor for the Troy YMCA's Camp Van Schoonhoven. He held the Charles A. Dana Endowed Chair at the University of Bridgeport. Currently, he is serving a term as the Connecticut state poet laureate (2010–2015). His poetry has appeared in hundreds of national publications, and he has edited science fiction works, including *Science Fiction: The Future* (1971). Allen is one of the founders of expansive poetry, a movement that began in the 1980s. He is considered a narrative poet, a Zen Buddhist poet, and sometimes a "new formalist." His numerous awards include the Pushcart Prize and six inclusions in the *Best American Poetry* annual volumes. Allen has received National Endowment for the Arts and Ingram Merrill Foundation poetry writing fellowships. He is considered one of America's leading poets. (Courtesy Dick Allen.)

CHAPTER THREE: SCIENTISTS, SDUCATORS, AND WRITERS

Dorothy Lavinia Brown (January 7, 1919–June 13, 2004) (BELOW)
Brown became the first African American woman surgeon in the South in 1948. She also was the first African American to serve in the Tennessee House of Representatives (1966). She spent most of her youth in a Troy orphanage, where her mother left her at five months old. She ran away from the orphanage and went to Troy High School (graduating as valedictorian), worked as a domestic, and later lived with foster parents. After obtaining a BA in 1941, she worked at a defense company in Troy. She studied medicine at Meharry Medical College in Nashville, graduating third in her class in 1948. She completed her residency at Hubbard Hospital in Meharry, where many doctors were uncomfortable with the idea of training a woman surgeon (she had also been banned from taking her residency in Harlem). While in the Tennessee legislature, she fought to legalize abortions in cases of rape or incest, and campaigned for the passing of the Negro History Act. She lost a bid to become a state senator due to her abortion stance. She taught surgery at Meharry Medical College and was attending surgeon at the George W. Hubbard and General Hospitals. She was the first single mother to adopt a child in Tennessee in 1956, and she became the third woman (and first African American) to become a Fellow of the American College of Surgeons in 1959. Russell Sage College in Troy gave her an honorary doctorate. (Courtesy National Library of Medicine.)

Dave Anderson (May 6, 1929–Present)
Troy-born Anderson has been writing his sports column for the *New York Times* since November 1971. Before that, he was a general assignment sports reporter with the paper beginning in 1966. He is the author of 21 books and hundreds of magazine articles, many in several anthologies, and was the recipient of the 1981 Pulitzer Prize for distinguished commentary for his sports column. Other awards include the 1994 Associated Press Sports Editors Red Smith Award for distinguished sports column writing, and the Nat Fleischer Award for excellence in boxing journalism (1974). He was inducted into the National Sports Writers and Sportscasters Hall of Fame in Salisbury, North Carolina, in 1990.

CHAPTER THREE: SCIENTISTS, EDUCATORS, AND WRITERS

Amos Eaton (May 17, 1776–May 10, 1842) (LEFT)

Trained as a lawyer, Eaton is best known for founding Rensselaer Polytechnic Institute (first known as the Rensselaer School) in 1824, the first college dedicated to studying science. He was the first to use field schools as a tool for education and wrote one of the first field guides to geology in 1818. In geology, much of the early 19th century is known as the Eatonian Era (1818–1836), as many of the field's leading minds were trained by him at Rensselaer School. In 1818, he founded the Troy Lyceum of Natural History, one of the first natural history societies. Eaton and his students floated down the newly opened Erie Canal and studied its rich geology and natural history in 1823 and 1824. This was the first use of outdoor education methods that are still common today. With the financial support of patron Stephen Van Rensselaer, Eaton mapped out the entire geological history of New York State. Eaton is buried at Oakwood Cemetery.

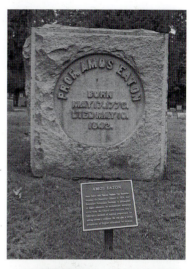

Silas Watson Ford (1848–June 25, 1895)

Ford started as a Troy telegraph operator and became a leading paleontologist after discovering fossils in Troy's Beman Park (pictured above). He found the first early Cambrian period fossils in North America, helping to resolve a geological controversy that had been going on for 30 years. In his short lifespan, Ford published more than 20 scientific papers. His seven-part series on geological processes in the *New York Tribune* in 1879 was so popular that Union College awarded him an honorary master's degree. Ford had either an alcohol or opium addiction and always seemed to be in debt, needing to borrow money. Eventually most of the geologists he had been corresponding with or working with abandoned him. His wife tried to sell off his fossil collection of 419 specimens and his 170-volume personal library to repay a debt of $72.20, which she inherited since Ford himself had been declared legally incompetent. The fossils were purchased by the state museum after her death. Ford died at the age of 47 in his cousin's home.

Bernd Foerster (December 5, 1923–November 8, 2010)
Bernd was a professor of architecture and early proponent of historic preservation in Troy. Born in the Netherlands, he graduated from RPI and was an instructor and associate professor before becoming dean. While at RPI, he was a founding member of the New York State Preservation Alliance. In 1960, he produced an antipollution film on the *"Assault on the Wyantskill,"* with Woody Guthrie singing "This Land Is Your Land" in the background. In addition, while in Troy he wrote a preservation book called *Architecture Worth Saving in Rensselaer County*, and he appeared in a documentary called *What Will They Tear Down Next* that showed the devastating effect urban renewal was having on Troy and surrounding areas in the late 1960s. He became professor and dean of the College of Architecture, Planning and Design at Kansas State University and was active in his community in a number of societies and organizations. (Courtesy Michael Lopez.)

CHAPTER THREE: SCIENTISTS, SDUCATORS, AND WRITERS

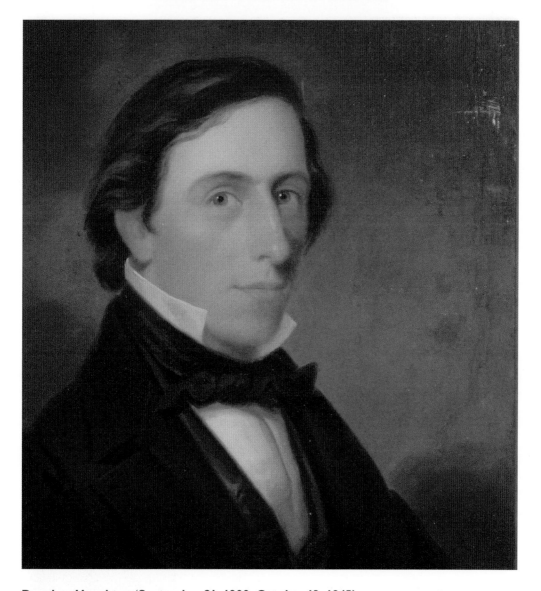

Douglass Houghton (September 21, 1809–October 13, 1845)
Houghton was a Troy-born geologist who studied under Amos Eaton at Rensselaer Polytechnic Institute during the Eatonian Era, a period in which most geologists of the country were students at RPI, the birthplace of the study of American geology. After graduating from RPI, he taught chemistry and natural history there. Later he became a medical doctor. The city of Detroit asked Eaton for a lecturer on geology and he recommended Houghton. Houghton is famous for studying Michigan's Keweenaw Peninsula and became Michigan's first state geologist, a position he held for life. He taught sciences at the University of Michigan at Ann Arbor. With Henry Rowe Schoolcraft, he explored the source of the Mississippi River in 1831, discovering new plant species and inoculating the local Native Americans against smallpox. He became mayor of Detroit in 1842 while he was exploring in the wilderness. He was a founding member of the Association of American Geologists and Naturalists. He drowned at age 36 while exploring Lake Superior and never reached his potential. The city of Houghton, Michigan, was named in his honor. (Courtesy of University of Michigan.)

87

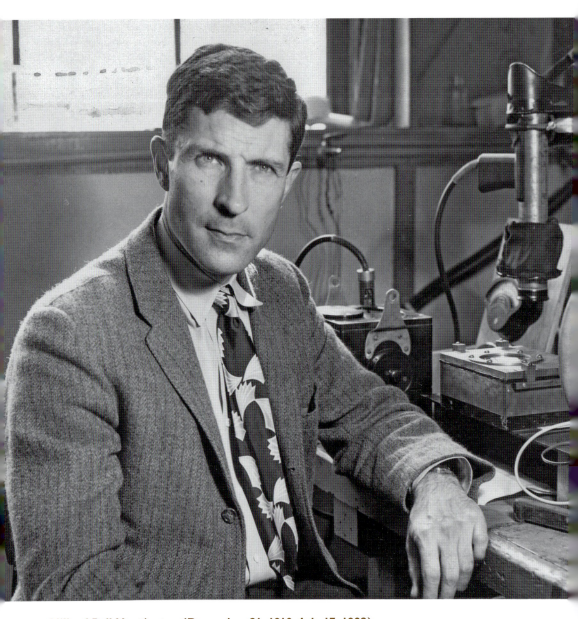

Hillard Bell Huntington (December 21, 1910–July 17, 1992)
Huntington was a physicist who began working at Rensselaer Polytechnic Institute in 1946 and served as the chair of the Physics Department for seven years (1961–1968). He specialized in the study of metals and proposed that hydrogen could exist in a metallic state in 1935. He was one of the world's first solid-state physicists and his research helped lead to the development of integrated circuits and computer chips. His research proved that movement of atoms caused repeated failure in circuits made of microscopically thin metal wire. This concept called electromigration marked a fundamental discovery in integrated electronics. RPI also awards the Hillard B. Huntington Award to graduate students for outstanding studies. Huntington was also an accomplished painter and served in cultural institutions in Troy. (Courtesy Institute Archives and Special Collections, Rensselaer Polytechnic Institute, Troy, New York.)

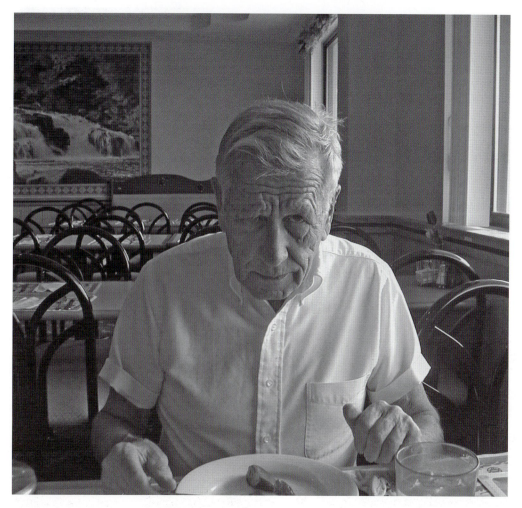

Louis Ismay (February 25, 1925–Present)

Ismay was the first director of the Junior Museum (1957–1964), a children's museum created by the Junior League and headquartered in the basement of the Rensselaer County Historical Society on Second Street for many years. He developed one of the first mobile exhibit programs, where artifacts and educational information were taken to schools instead of schools coming to a museum. During his tenure at the museum, he undertook some of the first archaeological excavations at Crown Point and the Albany Glass Works and produced educational programming at WMHT, the local PBS station. Lou also was the chair of the organizing committee that formed the Rensselaer County Council of the Arts and was their first president. He taught sociology at the Albany campus of the Russell Sage College. During a stay in the East Greenbush school district, he pioneered outdoor camping education programs for natural history teachers. In 1970, he taught a class called Environmental Forum at the University at Albany, a part of the Environmental Studies Program until its demise due to budget cuts in 1977. With the beginning of the environmental movement, Ismay encouraged his students to do practical hands-on learning rather than just sitting in a classroom. He brought weekly guest speakers to the class, including René Dubos, Pete Seeger, and Ralph Nader. Ismay taught students to take a proactive stance to their surroundings, both environmental and societal. Ismay currently lives in Altamont, New York. Many of his students went on to become movers and shakers in the environmental movement and continue to be active today. He currently produces his own public affairs television program.

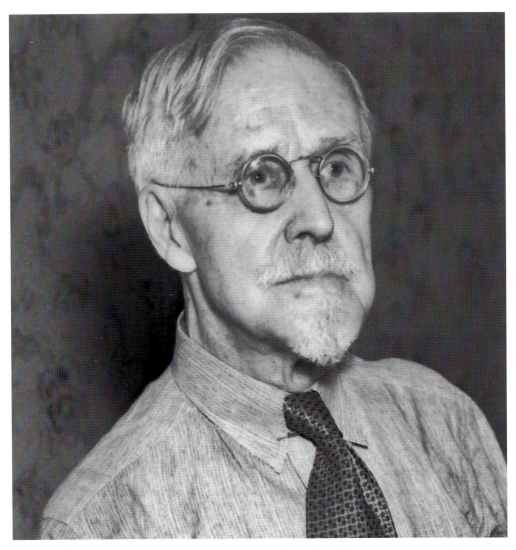

William Henry Jackson (April 4, 1843–June 30, 1942)
Jackson grew up in Troy and was a famous American painter and surveyor. His great-great-uncle was Samuel Wilson, America's Uncle Sam. While a teen in Troy, he used his drawing talent to design display cards for a local pharmacy and other stores, and painted landscapes on screens. He was commissioned in 1869 by the E. & H.T. Anthony & Company to supply them with 10,000 stereo views of the American West. He joined Ferdinand Vandiveer Hayden, head of the US Geological Survey, as official photographer until 1878. During this period, he photographed for the first time the Old Oregon Trail, Yellowstone, Mammoth Hot Springs, Tower Falls, the Rocky Mountains, and Mesa Verde. His images of Yellowstone helped convince Congress to establish Yellowstone National Park on March 1, 1872. Jackson continued for the next few years traveling and photographing, including 30,000 negatives of American railroads. In 1883, he became his own corporation, the W.H. Jackson Photograph and Publishing Company, Inc., and published several volumes of images on Mexico and Colorado. He later was hired by the Roosevelt administration to paint murals based on several surveys that had been done in the 1870s and 1880s. A few years before his death, he acted as a technical advisor for the filming of *Gone with the Wind*. (Courtesy of Library of Congress.)

CHAPTER THREE: SCIENTISTS, EDUCATORS, AND WRITERS

Erie Canal at Little Falls
This view of the Erie Canal at Little Falls was taken by Jackson around 1898. (Courtesy of Library of Congress.)

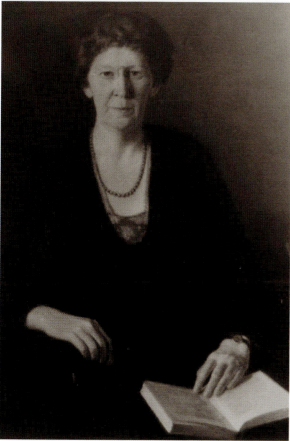

**Eliza Kellas
(October 4, 1864–April 10, 1943)**
Kellas spent most of her career as an educator. She was principal of the new Emma Willard School (formerly Troy Female Seminary) in Troy's East Side in 1911, and in 1916 she expanded the old campus (original Female Seminary) on Second Street into a new school called Russell Sage College of Practical Arts. She served as dean and president of the new school and retained principal status at Emma Willard. She was able to obtain a separate charter for the new school from the New York State Board of Regents, and in 1927 it became independent of Emma Willard School. During a period when Emma Willard had lost direction, Kellas was instrumental in keeping the school strong. (Photograph courtesy of The Sage Colleges' Libraries.)

Almira (Hart) Lincoln Phelps (1793–1884)

Hart was the vice president of Troy Female Seminary in 1824 and sister of school founder Emma Willard. Almira followed her sister's interest in teaching and at the age of 19 was in charge of an academy in Sandy Hill, New York. She married newspaper editor Simeon Lincoln in 1817, who published the *Connecticut Mirror* in Hartford, Connecticut. His death in 1823 left her with two children, but she still found the time to study Latin and Greek to qualify for a job teaching drawing and painting. She became vice principal of Troy Female Academy for seven years and in 1831 married Judge John Phelps of Guilford, Vermont. In 1838, she became the head of a seminary in West Chester, Pennsylvania, and she ran the Patapsco Institute in Maryland in 1841. Almira Phelps published a number of textbooks for women including *Lincoln's Botany* in 1820, *Geology for Beginners* in 1832, *Chemistry for Beginners* in 1834, and *Natural Philosophy and Lectures on Chemistry* in 1837. She also published several novels, such as *Caroline Westerly* in 1833 and *Ida Norma* in 1850.

Mary Louise (Parmelee) Peebles (December 10, 1833–April 25, 1915)

Peebles published under the pseudonym Lynde Palmer. She lived in Lansingburgh and attended the Lansingburgh Academy, the same school that Chester Arthur attended. She was married to Augustus A. Peebles. After her two children died, she began writing, specializing in children's books. Her four-book Magnet Series was a hit with children, selling more than 100,000 copies, a remarkable achievement for the era.

Herman Melville
(August 1, 1819–September 28, 1891)

Melville spent his early adulthood (1838–1847) in Lansingburgh near the intersection of 114th Street and First Avenue, which now houses the Lansingburgh Historical Society. Melville went to school at the Lansingburgh Academy. It was at his First Avenue home that Melville wrote his first two books, *Typee* and *Omoo*. Both became bestsellers, and during the 1840s he was a literary success. Many writers believe his voyages on the *Acushnet* were the primary inspiration for *Moby Dick*, but it is likely that the story of Whale Island right outside his bedroom window may have also played a role. Dutch legends refer to several whale sightings in the Troy area, and Melville, himself of Dutch extraction, knew the stories well. When Melville died, he was a relatively unknown figure; his works would not become popular again until many years after his death. (Courtesy of Library of Congress.)

Melville's Home
Melville's boyhood home is now used by the Lansingburgh Historical Society.

LEGENDARY LOCALS

Sidney Powers (1890–1932)
One of the most respected early geologists, Powers's work in petroleum geology in Oklahoma revolutionized the oil industry. He promoted the importance of looking underground for oil surficially, which was common at the time. This began the use of drill cuttings and geophysical prospecting. He published over 124 articles on how to find oil. He was a founding father of the American Association of Petroleum Geology, the largest geological society in the world, and each year they award the Sidney Powers Medal as their most prestigious honor. (Courtesy of Library of Congress.)

Richard Selzer (1928–Present)
Selzer is a Troy-born surgeon and author. A graduate of Schenectady's Union College and Albany Medical College, Selzer is probably better known as an author of over a dozen books including *Down from Troy: A Doctor Comes of Age*, his autobiography about growing up in Troy. The annual Selzer Prize was created in 2010 by *Abaton*, a medical humanities literary and arts journal produced by Des Moines University and created to honor Selzer for his contributions to the medical humanities and medical profession. The award is given annually to a medical student whose essay or story has a humanistic focus. (Courtesy Yale Office of Public Affairs & Communications.)

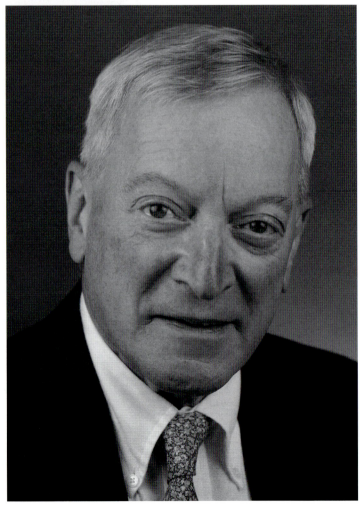

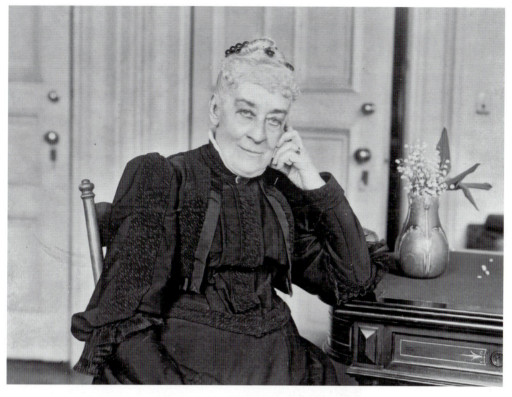

Margaret Olivia Slocum (September 8, 1828–November 4, 1918)
Slocum was a graduate of the Troy Female Seminary (Emma Willard School) in 1847 and went on to marry millionaire Russell Sage. Upon his death, she inherited $50 million that she used to promote women's causes. In 1916, she founded Russell Sage College in Troy, today recognized as one of the leading colleges in the country for women. The Russell Sage Foundation she established in 1907 continues her interests.

Russell Sage Campus
The Russell Sage campus (formerly Emma Willard campus) today, with the statue of Emma Willard.

Solita Solano (aka Sara Wilkinson, 1888–1976)

Wilkinson attended Emma Willard School in Troy and married an engineer, following him to the Philippines and the Orient. After returning to New York in 1908, she became a theater critic for the *New York Tribune* and a freelancer for the National Geographic Society. She changed her name to Solita Solano. Solita developed a lesbian relationship with journalist Janet Flanner, and they joined the intelligentsia of Gertrude Stein and Alice B. Toklas in Paris. Solita published three novels and a book of poetry, none of which were successful. During the 1930s and 1940s, she became part of The Rope, a group of disciples of mystic George I. Gurdjieff, and acted as his secretary. After his death, she held the group together and had affairs with other members of The Rope, including Margaret Anderson, founder of the *Little Review*, and Elizabeth Jenks Clark.

Solano and Djuna Barnes
Solano and writer Djuna Barnes in Paris in 1922. (Courtesy of Library of Congress.)

CHAPTER THREE: SCIENTISTS, SDUCATORS, AND WRITERS

Mary Warren (April 21, 1789–February 8, 1859)

Mary Bouton married into an established Troy family, marrying Nathan Warren on April 24, 1808. Mary continued a Saturday sewing class founded by Mrs. Phebe (Bouton) Warren, her mother-in-law, and after her death converted it into a day school, the first for disadvantaged girls. She was the founder and donor of the Church of the Holy Cross on Eighth Street in 1844, "a house of prayer for all people without money and without price." The school was incorporated on March 19, 1846, as The Warren Free Institute, for "the purpose of maintaining and conducting a free school." The name was later changed to The Mary Warren Free Institute of the City of Troy.

LEGENDARY LOCALS

Emma (Hart) Willard
(February 23, 1787–April 15, 1870)

Hart opened a school for girls in nearby Waterford in 1819. However, several of Troy's visionaries convinced the city to raise $4,000 in taxes to begin construction of a school for Willard. She moved into the Troy Female Seminary in 1821. Today it is known as Emma Willard School. The Seminary was the first such school, predating the first public high schools for girls in Boston and New York City by five years and the famous Mary Lyon's Mount Holyoke Seminary by 16 years. It was a pioneer in the teaching of science, mathematics, and social studies and the school attracted students from wealthy families. In a few short years, she had an enrollment of over 300 students, with more than 100 boarders. All textbooks at the time were written for men, so Emma wrote some of the first textbooks for women: *History of the United States, or Republic of America* (1828), *A System of Universal History in Perspective* (1835), as well as a volume of poetry, *The Fulfillment of a Promise* (1831). Emma headed the college until 1838, and continued to lecture and write. Some of her other publications included *A Treatise on the Motive Powers Which Produce the Circulation of the Blood* (1846), *Guide to the Temple of Time and* (1849), *Universal History for Schools* (1849), *Last Leaves of American History* (1849), *Astronography; or Astronomical Geography* (1854), and *Morals for the Young* (1857). The school was renamed for her in 1895. It moved to its existing location in 1910.

CHAPTER FOUR

Athletes and Entertainers

Trojans excelled in sports and entertainment. Troy had one of the first professional baseball teams in America with the Haymakers, and they also crossed ethnic barriers when Steve Bellan, the first Latino, played for them. Five Trojans have made it to the Baseball Hall of Fame, and the catcher's mitt was invented here. Three of America's first heavyweight boxing champs came from Troy, and one of them created the Saratoga Racetrack, one of the premier racing establishments in the country. One of the most influential plays in American history, *Uncle Tom's Cabin*, had its US debut in Troy and played for more than 100 days. Two important modern musical groups, Blood, Sweat & Tears and Manhattan Transfer, were founded by Trojans Richard Halligan and Tim Hauser respectively. Maureen Stapleton won every acting award possible, and Helen Ford was the lead in *Helen of Troy, New York*, one of George Kaufman's first plays, spoofing the collar industry of Troy. Trojans created sports and entertainment history and their contributions still are remarkable after all these years.

George L. Aiken (December 19, 1830–April 27, 1876)

Aiken's stay in Troy was a brief one, but nonetheless made a lasting impression on the American public. Aiken wrote the theatrical version of Harriet Beecher Stowe's Uncle Tom's Cabin. On September 27, 1852, the play opened at Peale's Museum on the corner of Fulton and River for a remarkable run of 100 performances. Aiken played the role of hero George Harris. Before Uncle Tom, he was a writer of dime novels and after Uncle Tom wrote a dramatization of Anne S. Stephen's *The Old Homestead*. He retired in 1867.

Esteban Enrique Bellán aka Steve Bellan (October 1, 1849–August 8, 1932)

Known as the "Cuban Sylph," Bellan was the first Latin player in American baseball. While at Fordham University from 1863 to 1868, he played for the Fordham Rose Bill Baseball Club, a team that played the first nine-player college baseball game in the United States on November 3, 1859, against the St. Francis Xavier College team. In 1869, Steve joined the Troy Haymakers and played third base until 1872, when the Haymakers folded. He returned to Cuba and played in the first organized Cuban game, and served as player and manager of the Habana team from 1878 to 1886. That team won the Cuban championships in 1878–1879 and 1882–1883 and is considered one of the most legendary in Cuban baseball history. (Courtesy Fordham University Archives.)

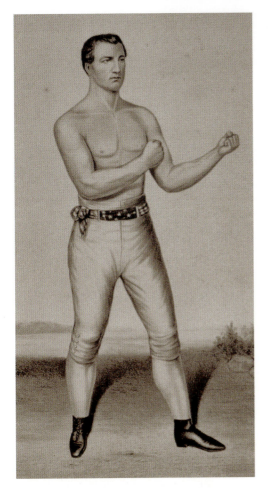

Benecia Boy, John Camel Heenan (May 2, 1835–1873)

Heenan was born in Troy to an Irish immigrant family. He stood tall at six foot two inches and weighed between 182 and 195 pounds. While working swinging a sledgehammer at the Pacific Mail Steamship Company repair yards in Benicia, California, he was nicknamed the Benicia Boy. Heenan became a boxer and fought Trojan John Morrissey for the heavyweight championship in 1858 but broke his right hand and lost. He was known as the first American boxer to work out with weights and punching bags to get in shape. His fight with English champ Thomas Sayers on April 17, 1860, was a draw after 38 rounds. Both received belts. Heenan married Adah Isaacs Menken, the famous San Francisco actress. She divorced him because he beat her every night after dinner. He is buried in Menands and was elected to the Ring Boxing Hall of Fame in 1954, the third champion boxer from Troy to be so honored.

Big Dan Brouthers (1858–1932)

Brouthers was a member of the famous Troy Haymakers baseball team in 1879. Sent back to the minors for making too many errors, he returned to the majors to lead the league in batting average in 1882–1883, 1889, and 1891–1892, in home runs in 1881 and 1886, and in RBIs in 1892. Brouthers won the batting title with a .373 average in 1889 for the Boston Beaneaters, and in 1891 hit .350 to win another batting crown with the pennant-winning Boston Rods of the American Association. Brouthers ended his career with a .343 batting average, ninth best of all time. When his playing career ended, he worked as a press box attendant at the Polo Grounds until he died in 1932. He was elected to the Hall of Fame in 1945. (Courtesy of Library of Congress.)

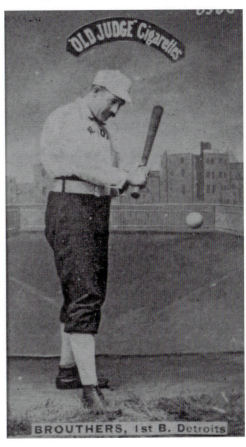

Roger Connor (July 1, 1857–January 4, 1931)
Connor was the Babe Ruth of his time, hitting 138 homers. He began his career with the Troy Trojans (successors of the Haymakers) in 1880. In the three years he played with Troy, he played in 249 games, scored 173 runs, and had 335 hits with 9 homers and 120 RBIs. After the Trojans disbanded, he played for the New York Gothams (later Giants) and consistently led in batting (in the top ten for a decade) and home runs until he retired in 1897. The six foot three inch, 200-pound Connor played first base, although he started his career as a third baseman. It took 24 years before Babe Ruth would topple his record for most career home runs on July 18, 1921. He later managed minor-league teams in Waterbury, Connecticut, and was an inspector of the public schools there. He was the first to hit a home run at the Polo Grounds and one of five Trojans elected into the Hall of Fame, inducted in 1976. His nickname was "Dear Old Roger." (Courtesy of Library of Congress.)

CHAPTER FOUR: ATHLETES AND ENTERTAINERS

William H. Craver (June 13, 1844–June 17, 1901)
Craver was a Troy-born infielder and catcher who was one of the earliest members of the Lansingburgh Union (1867–1870) and Haymakers (1871) baseball teams. He also managed both teams. He was implicated in the Louisville Grays gambling scandal in 1877, although there was no evidence against him; he simply refused to cooperate with the investigation and was banned. He then served as a Troy policeman from 1893 until his death.

LEGENDARY LOCALS

James H. "Jim" Devlin (April 16, 1866–December 14, 1900)
Born in Troy, Devlin was a baseball pitcher who had a short-lived career playing for three teams, including the New York Giants between 1886 and 1889. He had an 11–10 win/loss record with a 3.38 ERA and 90 strikeouts. He is sometimes confused with pitcher Jim A. Devlin, who was banned for life from baseball after accepting money from gamblers in the 1877 Louisville Grays scandal (there have been at least three Jim Devlins who have played professional baseball). At the age of 34, he died in Troy from typhoid fever. (Courtesy of Library of Congress.)

John Joseph Evers (July 21, 1883–March 28, 1947)
Known as "The Trojan," the Troy-born Evers was one of the most famous pivot men (playing second base) in organized baseball. The famous Tinker to Evers to Chance double play combination helped lead Chicago to four National League pennants and two world championships in 1907 and 1908. He led the Boston Braves into the World Series in 1914; he batted a whopping .438 in the Series and was voted MVP. Evers managed three teams in his career: the 1913 Chicago Cubs, the 1921 Cubs, and the 1924 Chicago White Sox. He posted a 180–192 record as a manager. He later became the business manager and field manager of the International League's Albany Senators, who played in Hawkins Stadium in Menands. Evers was elected to the Hall of Fame in 1946 and is the only Baseball Hall of Famer from Troy who is buried in Troy. (Courtesy of Library of Congress.)

William "Buck" Ewing (October 17, 1859–October 20, 1906)

Ewing was one of the Troy Trojans and played for two years (1880–1882), playing catcher in 1880–1881 and third base in 1882. He joined the New York Gothams (later Giants) in 1883 and that year hit .303 and was the first batter to hit 10 homers in one season. He was known as an excellent fielder and was a swift baserunner, stealing a total of 354 bases. He hit 71 home runs during his career. He also managed several seasons with the New York Giants and Cincinnati Reds and led the Giants to their first world championship in 1888–1889. In 1939, he was the first catcher elected to the Baseball Hall of Fame. Many consider him to be the greatest all-around player of the 19th century. (Courtesy of Library of Congress.)

Helen Ford (June 6, 1894–January 19, 1982)

Ford was born in Troy. She became a major star on Broadway during the 1920s and acted in three Rodgers and Hart musicals. While married to her husband George Ford, she had an affair with Richard Rodgers. She appeared in *The Gingham Girl* in 1922, a big success. She followed that up with a Troy-based musical called *Helen of Troy, New York*, a two-act spoof on the collar industry written by George S. Kaufman and Marc Connelly. This successful 1923 play based on the writings of Kaufman was performed at Selwyn Theatre (June 19–October 7, 1923) and Times Square Theatre (October 8–December 1, 1923). It had a total of 191 performances. Helen sang a number of original songs in the play, with music and lyrics by Bert Kalmar and Harry Ruby (who also wrote music for the Marx Brothers' *Animal Crackers*, the nonmusical portion of which was written by George Kaufman and Morrie Ryskind).

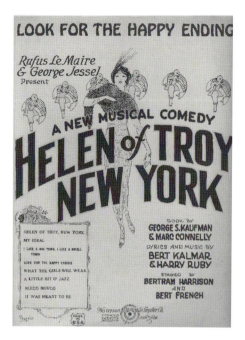

Helen of Troy, New York
(June 19, 1923–December 1, 1923)

Helen was an iconic fictional collar worker who was the center of the play by that name written by George Kaufman and Marc Connelly. The two-act musical comedy was produced by Rufus LeMaire and George Jessel with music by Bert Kalmar and Harry Ruby, and was orchestrated by Arthur Lange. There were 13 songs. Bertram Harrison and Bert French directed the play, which starred, ironically, Helen Ford (see page 107), who was also born in Troy. The play was a satire on the collar industry of Troy and in particular Cluett Peabody & Son, which had launched the most successful advertising campaign in America at the time, the Arrow Collar Man. More recently a rock song called "Helen of Troy, New York" was recorded by the band Span of Sunshine. There also was a book entitled *Helen of Troy, New York* by Wilfred S. Jackson in 1905, based on a fictional woman named Helen Helmer, a wealthy Trojan who goes to Europe.

Freddie Freihofer (1949–1966) (RIGHT ABOVE)

Freddie was an imaginary bunny created by WRGB Channel 6 television and sponsored by Freihofer Bakery. The show was called *Breadtime Stories* but was commonly known as the *Freddie Freihofer Show*. The young audience was made up of kids from the Capital District who had their birthday that day. The host of the show would tell a story and draw the famous "squiggles" on paper, often getting the kids to take part. Part education, part entertainment, Freddie was on the air for 15 minutes from 4:45 to 5:00 p.m., five days a week, 52 weeks a year for 17 years from 1949 to 1966. It was a pioneer in live TV and was the first local show to be broadcast in color. A total of 4,400 shows were broadcast including one during the 1964 ice storm, during which one kid showed up from Hudson, New York. During the show's run, a quarter of a million kids participated, with every kid receiving one of the Freihofer's famous fruit-filled cookies as a reward for being on the show. Kids at home participated in drawing lessons. There were four hosts of the show, starting with Ralph Kenna (1949–1955), who became a successful cartoonist and TV kids show host elsewhere. The second was Ed Joyce in 1955, but he only stayed a short time. He devised the famous "squiggles" and introduced Cookie the monkey to the show. Joyce went on to become president of CBS News in 1983. The third host, Harry Bud Mason, was hired to replace Joyce but was killed in a car accident. The last host and perhaps most associated with the show was Jim Fisk, who was on staff when the show was first conceived in 1949. After the demise of the show, Fisk created a mapmaking company that is still in business. Freihofer's at one time was the largest bakery in the world. Many baby boomers still remember the song sang at the beginning of each show:

Oh Freddie, we're ready, we're waiting for you.
Freddie, we love everything that you do.
We love your bread, your cake and your pies.
We love the way you roll those funny bunny eyes.
Freddie Freihofer, we think you're swell.
Freddie, we love the stories you tell.
We love your cookies; your bread and your cake.
We love everything Freddie Freihoifer bakes.

Freihofer's Horse Delivery (RIGHT BELOW)

Kids were awakened in the morning by the hoof sounds of Freihofer's horse delivery.

CHAPTER FOUR: ATHLETES AND ENTERTAINERS

109

LEGENDARY LOCALS

Robert Fuller
(July 29, 1933–Present)

Robert Fuller was born in Troy as Buddy Lee. He grew up to become one of television's most famous western actors, spending more than 50 years as a star in dramas such as *Laramie*, *Wagon Train*, and *Emergency!* Before his rise on TV, he appeared in a number of movies, such as *Gentlemen Prefer Blondes* with Marilyn Monroe, *Friendly Persuasion*, and *Teenage Thunder*. Fuller has a star on the Hollywood Walk of Fame and was inducted into the National Cowboy and Western Heritage Museum in Oklahoma City (2007). In recent years, he has acted in *Walker, Texas Ranger*, and *JAG*. He currently lives in Texas with his wife, Jennifer Savidge. (Courtesy of Robert Fuller)

Fuller as Jess Harper
Playing Jess Harper on *Laramie* for four years made Robert Fuller a household name. (Courtesy of Tony Gill.)

CHAPTER FOUR: ATHLETES AND ENTERTAINERS

Franklin Fyles (November 1894–July 4, 1911)
Fyles was born in Troy and became famous as the drama critic for the *New York Sun* for 30 years. He made his fortune from his play *The Girl I Left Behind*, which was performed at the Empire Theater in the early 1890s. Fyles started in the paper business and was only 20 years old when he began writing for the *New York Sun* as a police reporter in 1870. He became their drama critic in 1885 and kept that position until 1903. He wrote several short stories and a book called *The Theater and Its People*. In addition to *The Girl I Left Behind*, written with David Belasco, he also wrote the plays *The Governor of Kentucky* (1896), *Cumberland '61* (1897), *A Ward of France* (1897), *Kit Carson* (1901), and *Hearts Courageous* (1903). He was married with two children and was 64 when he died. He was considered the dean of New York critics. In an 1895 interview, he wrote, "An actor or a playwright does not perpetrate a crime when he makes a failure," and "The business of the critic is to criticize." (Courtesy New York Public Library.)

Richard Halligan (August 29, 1943–Present)
The Troy-born Halligan is a famous musician and composer known as a founding member of Blood, Sweat & Tears, a popular jazz-rock band that began in 1967 and continues today. Dick played trombone and later piano, organ, and flute. For his performance on *Variations On A Theme by Erik Satie* (on Blood, Sweat & Tears's second album, in 1968), he won a Grammy Award, and has two other nominations. Besides playing, he also wrote and arranged many of the group's songs. He left Blood, Sweat & Tears in 1971 and continued to compose and arrange music for movies (14 titles), television, and commercials.

CHAPTER FOUR: ATHLETES AND ENTERTAINERS

Tim Hauser (December 12, 1941–Present)
Tim (standing on the left) is a Troy-born singer and is best known as the originator of the singing group Manhattan Transfer, which he formed in 1969. He was also a Madison Avenue marketing executive for a short time. After the group broke up in the early 1970s, he continued singing and driving a taxi to make a living until he re-formed the group with Laurel Massé, Janis Siegel, and Alan Paul. Their album in 1975 produced the hit "Operator," giving them national recognition. In 1975, Manhattan Transfer had an hour-long TV show on Sunday night at 8:00 p.m. (the original Ed Sullivan hour). Massé left the group and was replaced by Cheryl Bentyne in 1978. Hauser's group has won 10 Grammys (12 nominations), two of them in the same year in two different categories. Tim served on the original voting committee of the Rock and Roll Hall of Fame for its first three years (1986–1988). Manhattan Transfer continues to make great music. (Courtesy Tim Hauser.)

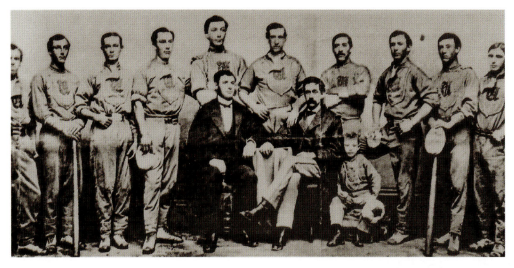

Troy Haymakers (1861–1872)

The Haymakers was a professional baseball team that produced several Hall of Famers. Established in 1861 as the Union Baseball Club in Lansingburgh (combining two teams, the Priams of Troy and the National Club of Lansingburgh), the team made history by being in the first pennant race in 1869 and became a member of the first professional baseball league, the National Association of Professional Base Ball Players, in 1871. They played at Rensselaer Park between 108th and 110th Streets, on Center Island and elsewhere. After defeating the New York Mutuals in 1867, one of the opposing players expressed disbelief that they lost to a bunch of upstate "haymakers." The name stuck. They went broke halfway through their 1872 season and dissolved on July 24, even though they had a 15–10 record at the time.

On January 26, 1879, the new Lansingburgh Haymakers changed their name to the Troy Trojans. They did not do well and had a total of 134 wins and 191 losses. In 1882, they were asked to leave the National League along with the team from Worcester, Massachusetts. Both cities were given the distinction of becoming honorary members of the National League, which still holds today. Many of the members of this team played later for the New York Metropolitans of the American Association and the Gothams of the National League. Nearly half of the Gotham players (today's San Francisco Giants) were former Trojan players. Of the 76 or so players that played for the various versions of the Haymakers between 1866 and 1882, five players landed in the Hall of Fame at Cooperstown: Dan Brouthers, Roger Connor, William "Buck" Ewing, Timothy Keefe, and Smiling Mickey Welch. There is a monument to the team at Knickerbocker Park in Lansingburgh.

Hugh Joseph (Hughie) Hearne (April 18, 1873–September 22, 1932)

Hearne was a catcher who batted .289 over eight seasons. He began playing in the old New York State League, playing with the Albany and Troy teams, and later for the Eastern League Baltimore and Newark clubs. Baltimore sold him to Newark for $500. He played with the Albany Senators from 1899 to 1901, leading the league in batting with a .380 average in 1901. His friends knew him as "Hughey," and one obituary said he was one of the game's best catchers when he played with the Brooklyn Superbas from 1901 to 1903. He was also known as a great baserunner. He retired in 1910.

Michael "King" Kelly (December 31, 1857– November 8, 1894)

Kelly was a Troy-born professional baseball player who began with the Cincinnati team (Red Stockings) in 1878 and played most of his career with the Boston Beaneaters and Chicago White Stockings. A right fielder, catcher, and later a manager, he is considered one of the greatest baseball players of all time. He stole at least 50 bases four years in a row, with a high of 84 in 1887. He was a player on eight pennant-winning teams in 16 years and won the National League batting title in 1884 (.354) and 1886 (.388). He is credited with inventing the hook slide. His $10,000 salary was considered by some to be excessive in 1886. He wrote the first baseball autobiography in 1888 called *Play Ball Stories of the Diamond Field*. He became a popular icon with the song "Slide Kelly Slide," considered to be the first "pop" song recorded. A film by that name was released in 1927. Kelly himself took up acting in vaudeville. In 1945, he was elected to the Baseball Hall of Fame.

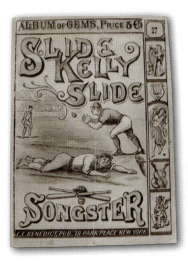

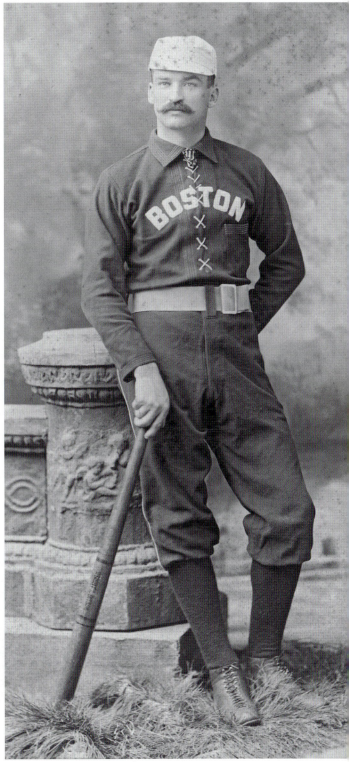

George C. Howard (1818–1887) (LEFT)

Howard was an American actor and theater operator who became famous for his performance in *Uncle Tom's Cabin*, which debuted in Troy on September 27, 1852, and ran for 100 consecutive nights (three months) at Peale's Museum. The three-hour play was written by Howard's wife's cousin, George Aiken. The play was mostly a family affair with George playing Augustine St. Clare, his wife Caroline playing Topsy, and daughter Cordelia playing Eva. Cousin George played George Harris. In 1857, Howard managed the Troy Adelphi Theater. The play continued in production until the 1930s. Caroline Emily Fox Howard (1829–1908), Howard's wife, continued to play Topsy until her husband's death in 1887. Cordelia Howard (1848–1942) had a successful career as a child actor and left the profession when she married Scottish bookbinder Edmund J. MacDonald in 1871.

Caroline and Cordelia Howard

Caroline, George's wife, played Topsy in *Uncle Tom's Cabin*, and Cordelia, George's daughter, played Eva.

117

Sadie G. Koninsky (August 1879–January 2, 1952)

A music composer, teacher, and publisher, Koninsky is credited with writing more than 300 songs, which included waltzes, marches, and ragtime songs popular during the late 19th century and into the 20th. Her 1898 hit "Eli Green's Cake Walk" was the first published by a woman. She and her brother Maurice started their own music publishing business called M.N. & S. Koninsky, followed by Edw. M. Koninsky & Brothers in 1899. She was considered the "genius of the firm," according to the *Music Trade Review* in 1900. In 1904, she and her brothers formed the Koninsky Orchestra and performed for more than 20 years. The company became the Koninsky Music Company and they sold their music through Frear's Department Store. They lived at 17 King Street. During the 1920s, Sadie had her own publishing company, Goodwyn Music Publishers, and taught private lessons, outliving her brothers.

James Lewis (1838–1896) (RIGHT)

Lewis was a 19th-century comedian, slim and short with blue eyes and reddish-brown hair. He entered acting by accident when he was teaching school in Troy. An actor friend asked him to take his part for a night at the Troy Museum in 1858 in a minor role in *The Writing on the Wall*. The friend never returned, and Lewis played the part for the entire run. He started in burlesque (Mrs. John Wood's Burlesque at the Olympic Theater and Lina Edwin's Theater) and then beginning in 1869 played with one company for over 20 years, the Augustin Daly Company. He had an international reputation as an excellent comic actor and comedian, and had a long acting relationship with the famous actress Caroline Gilbert. He later toured with Gilbert across the country under the management of Henry E. Abbey, but both went back to Daly when he opened his Fifth Avenue Theater, a small playhouse that was known as the "parlor home of comedy" until it burned in 1873. For a time Lewis also teamed with comedian Henry Hotto, and together they were known as "the two young old men" playing old men at the Albany Theater in 1852 and 1853. Later from 1882 to 1891, they both played and toured the country in various Daly plays.

Lewis Performing (RIGHT INSET)

Lewis performing with Gilbert in *7-2-28.*

CHAPTER FOUR: ATHLETES AND ENTERTAINERS

Mrs. Gilbert and James Lewis in "7-20-28"
From a photograph by Sarony, New York. In the collection of Evert Jansen Wendell, Esq.

Thomas Howard Lewis (July 8, 1901–May 20, 1988)
Lewis was a Troy-born producer and writer of television shows and former husband of TV legend Loretta Young. He was a writer, producer, and executive at Young & Rubicam before World War II, and during the war he established the Armed Forces Radio Service, getting Hollywood and Broadway celebrities on the air. He received a number of awards for his efforts, including the Legion of Merit and the Excellent Order of the British Empire for those efforts. A graduate of Schenectady's Union College, he was the executive producer of the Loretta Young Show for 32 episodes in 1953 and 1954. He also produced episodes of Fireside Theater, and the movies *The Indiscreet Mrs. Jarvis* and *Cause for Alarm*. While on their honeymoon in Hawaii, Lewis and Young were guests of Admiral Isaac Kidd on the battleship USS *Arizona*; only months later, Kidd was killed on the bridge when the Japanese attacked Pearl Harbor. They were divorced in 1970. While Young continued in show business, Lewis did not. Instead he became director and part owner of the Beverly Hills Hotel and the Beverly Wilshire Hotel. He launched the Screen Guild Theater, a radio program that aired from 1939 to 1952, and he used profits from the show to help start the Motion Picture and Television Country Home and Hospital in the San Fernando Valley.

John Morrissey (February 12, 1831–May 1, 1878)

Morrissey was a New York gang member, boxer, and politician during the 1850s. His early years were filled with trouble; he became a thief, and before he reached the age of 18, he was arrested for crimes including assault with the intent to kill. He also was a bouncer in a South Troy brothel before leaving for New York City. He earned the nickname "Old Smoke" during a fight with Tom McCann. He was pinned with his back on top of burning coals from an overturned stove. While standing with his back smoking, he beat the pulp out of McCann. Morrissey won the American heavyweight title by fighting Yankee Sullivan (James Ambrose) in 1853, but he won because Sullivan misunderstood the rules. Morrissey was clearly beaten but won the title. He defended it against another Trojan, John H. Heenan, the Benicia Boy, and beat him in 11 rounds. Morrissey established the now famous Saratoga Racetrack in Saratoga Springs, depicted in a poor light in the accompanying *Puck* magazine spread, and went into politics. He served two terms in the House of Representatives (1867–1871) and helped bring down Tammany Hall boss William Tweed. He was then elected to the US Senate in 1875 and reelected in 1877. He was elected to the International Boxing Hall of Fame in 1996. (Courtesy Library of Congress.)

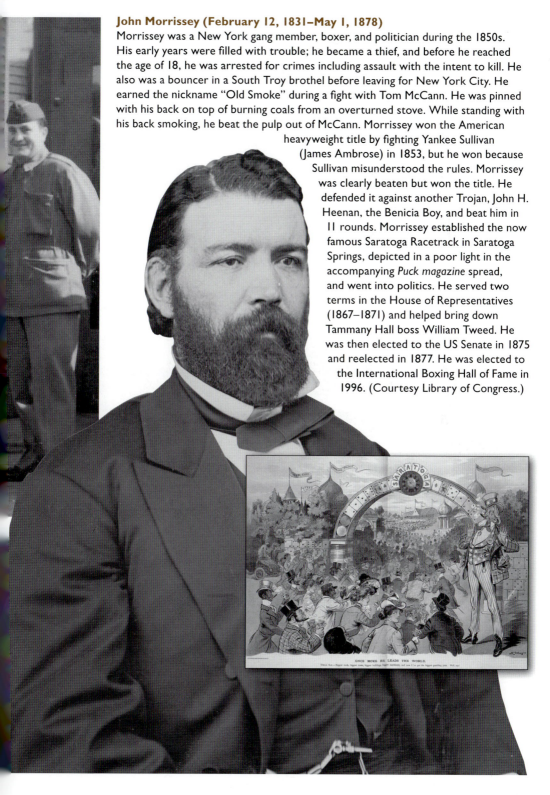

**Mary Nash
(August 15, 1884–
December 3, 1976)**

Nash was a Troy-born American vaudeville, stage, and screen actress whose career spanned 40 years. She was born Mary Ryan but took the Nash name after a booking agent and stockbroker, Philip Nash, of Troy's United Booking Office (largest vaudeville booker in the country) and head of the Leland Opera House, remarried her mother. She often played shy, unassuming women who turned mean. She made her Broadway debut on Christmas Day in 1905 with Ethel Barrymore in *Alice Sit by the Fire*. She also performed in *Uncle Tom's Cabin* in 1933, which had its national debut in Troy in 1862. She turned to film in 1936 and worked with Shirley Temple in the 1937 classic *Heidi* and the *Little Princess* in 1939. She also played opposite Spencer Tracy and Katharine Hepburn. She acted in more than two dozen films during the 1930s and 1940s. She was the older sister of comedic actress Florence Nash. The sisters acted together only once, in a play called *The Two Orphans* in 1926. (Courtesy Library of Congress.)

Florence Nash
(October 2, 1888–April 2, 1950)

Born in Troy as Florence Ryan, Nash began her acting in 1907 in the comedic *The Boys of Company B*. She also tried vaudeville. Her first hit was in 1912 playing the wisecracking Aggie Lynch in *Within the Law*. She became a star with her performance in *The Man Who Came Back* in 1916. Her movie debut was in the 1939 MGM hit *The Women*, adapted from a play by Clare Boothe Luce. In 1916, she was given a library of books, antiques, and items worth $50,000 from her uncle John Mack, a noted sportsman and politician in Albany. Mack was the brother of Mary and Florence's mother. (Courtesy Library of Congress.)

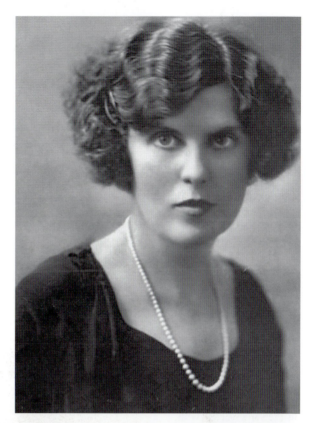

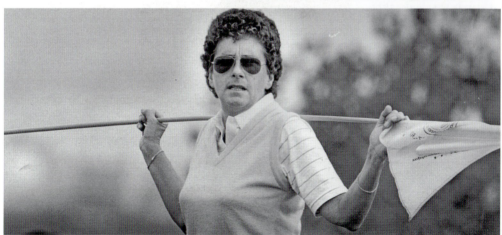

Mimi Ryan (April 1, 1936–Present)
Ryan is a Troy-born college golf coach who led the Florida Gators to NCAA titles in 1985 and 1986 as well as winning SEC coach of the year those two years. She also was national coach of the year in 1986. In 1986, the entire team was given All-American status, a first in NCAA history. The University of Florida sponsors the Mimi Ryan Lady Gator Endowment. She coached the Gators for 25 years, and the Gators also won several Southern Conference championships under her leadership. (Courtesy University of Florida Communications.)

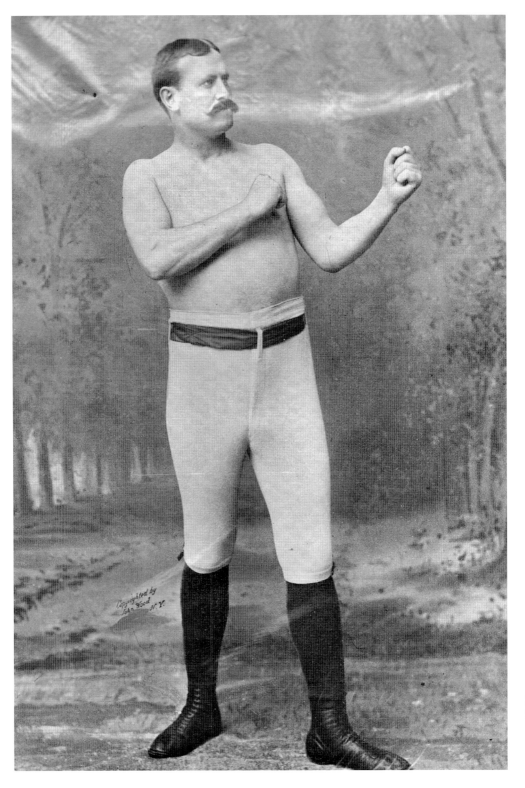

Patrick Henry "Paddy" Ryan (March 15, 1851–December 14, 1900) (LEFT)

Ryan was a saloonkeeper and bare-knuckle American boxer from Troy who won the heavyweight championship from Joe Goss in 1880. He lost his title two years later fighting John L. Sullivan. Known as the Trojan Giant, he owned a saloon in the famous Watervliet "Sidecut," a section of the Erie Canal in Watervliet across from Troy, and a location for many drinking holes. RPI athletic director Jimmy Kiloran once trained Paddy. Paddy and Sullivan fought a dozen times more, but he never won. He was elected to the Boxing Hall of Fame in 1973.

Maureen Stapleton (June 21, 1925–March 13, 2006)

Maureen was born in Troy on First Street as Lois Maureen Stapleton and was one of the leading actresses of her time. She performed in 22 plays and was nominated many times for awards, winning six Tony Awards, an Oscar, and an Emmy. Her autobiography *Hell of a Life* reveals a tough childhood in Troy. She was married twice, had problems with alcohol, which she overcame, and was a heavy smoker. She loved doing crossword puzzles and playing charades in her home in Lenox, Massachusetts, where she died in 2006.

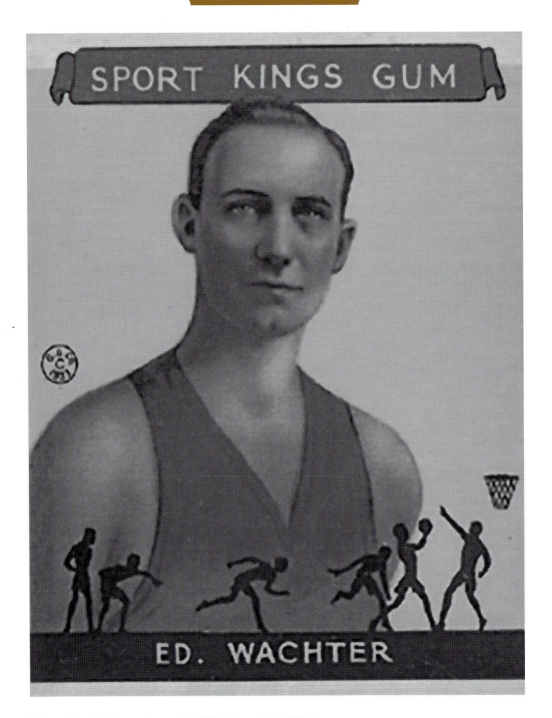

Edward A. Wachter (June 30, 1883–March 12, 1966)
The Troy-born Wachter was one of America's first professional basketball players, playing from 1899 to 1924. Standing six foot one inch, he helped lead the Troy Trojans to five league titles. He later coached for Harvard, Williams College, and Albany State Teachers College (now University at Albany). He is credited with inventing the bounce pass. In 1961, he was elected to the Basketball Hall of Fame.

INDEX

Aiken, George L., 100
Allen, Dick, 82
Anderson, Dave, 83
Arrow Collar Man, 32
Arthur, Chester Alan, 10
Baker, George Fisher, 33
Baker, Thomas A., 19
Baltimore, Garnet Douglass, 60
Bellán, Esteban Enrique (aka Steve Bellán), 100
Black, Frank Swett, 11
Boutelle, Frazier Augustus, 20
Brouthers, Big Dan, 101
Brown, Dorothy Lavinia, 83
Burden, Henry, 34
Burleigh, Lucien Rinaldo, 61
Butler, Harriet, 62
Carr, Joseph B., 21
Chambers, Thomas, 63
Cluett, Sanford, 35
Connolly, Cathy, 23
Connolly, James, 11
Connor, Roger, 102
Corbett, Thomas P. (Boston), 22
Craver, William H., 103
Crocker, Charles, 36
Cummings, Marcus F., 64
Daly, John, 65
Devlin, James H. "Jim", 104
Diamond, Jack "Legs", 66
Eaton, Amos, 84
Eaton, Joseph O., 38
Eaton, Orsamus, 37
Eddy, Titus, 39
Erickson, Carl, 67
Evers, John Joseph, 105
Ewing, William "Buck", 106
Fahey, Mary Alice (Mame Faye), 40
Farrell, Thomas Francis, 23
Ferris, George Washington Gale, Jr., 41
Fitchfield, Theodore, 42
Foerster, Bernd, 86
Ford, Helen, 107
Ford, Silas Watson, 85
Frear, William H., 43
Freihofer, Freddie, 109
Fuller, Robert, 110
Fyles, Franklin, 111
Garnet, Henry Highland, 68
Gilbert, Uri, 44
Ginsburg, Art, 71
Griffith, Griffith P., 45
Griswold, John A., 12
Gurley, William E., 46
Halligan, Richard, 112
Hammond, Jay Sterner, 12
Hands, Robinson, 12
Hauser, Tim, 113
Havermans, Peter, 69
Hearne, Hugh Joseph (Hughie), 115
Hedley, John, 47
Heenan, John Camel, 101
Helen of Troy, New York, 108
Horowitz, Sanford J. "Sandy", 48
Houghton, Douglass, 87
Howard, Caroline, 116
Howard, Cordelia, 116
Howard, George C., 116
Hubbard, Lucius Frederick, 13
Huntington, Hillard Bell, 88
Ismay, Louis, 89
Jackson, William Henry, 90
Judah, Theodore Dehone, 49
Kellas, Eliza, 91
Kelly, Michael "King", 117
Koninsky, Sadie G., 118
LaMountain, John, 24
Lansing, Abraham Jacob, 70
Lewis, James, 119
Lewis, Thomas Howard, 120
Lincoln, Almira (Hart), 92
Marcy, William L., 13
Marshall, Benjamin, 50
McCabe, Edward P., 16
McColl, William Patrick, 51
McNamara, Francis Terry, 25
Melville, Herman, 93
Meneely, Clinton H., 52
Montague, Hannah Lord, 72
Morrissey, John, 121
Mullany, Kate, 73
Murphy, Edward, Jr., 14
Nalle, Charles, 74
Nash, C. Howard, 75
Nash, Florence, 122
Nash, Mary, 122
O'Brien, William J., 26
Pattison, Edward W., 14
Peebles, Mary Louise (Parmelee), 92
Phelps, George M., 53
Pine, James K.P., 54
Poulton, George R., 76
Powers, Deborah, 77
Powers, Sidney, 94
Robinson, Henrietta, 80
Ross, Robert, 15
Ryan, Mimi, 123
Ryan, Patrick Henry "Paddy", 124
Sage, Russell, 55
Selzer, Richard, 94
Shea, Bartholomew "Bat", 78
Slocum, Margaret Olivia, 95
Solano, Solita, 96
Spafford, Horatio Gates, Jr., 79
Spafford, Horatio Gates, Sr., 79
Stapleton, Maureen, 125
Stewart, Philo Penfield, 56
Sweet, Herbert J., 27
Taylor, John, 57
Thomas, George Henry, 28
Townsend, Martin I., 16
Troy Haymakers, 114
Vanderheyden, Dirk, 80
Varnum, Charles Albert, 29
Wachter, Edward A., 126
Warren, Mary, 97
Waters, Eliza, 58
Waters, George, 58
Wilkinson, John, 18
Willard, Emma (Hart), 98
Wilson, Samuel, 17
Winslow, John F., 59
Wool, John, 30

Find more books like this at
www.legendarylocals.com

Discover more local and regional history books at
www.arcadiapublishing.com

Consistent with our mission to preserve history on a local level, this book was printed in South Carolina on American-made paper and manufactured entirely in the United States. Products carrying the accredited Forest Stewardship Council (FSC) label are printed on 100 percent FSC-certified paper.